C.C.WANG
LANDSCAPE PAINTINGS

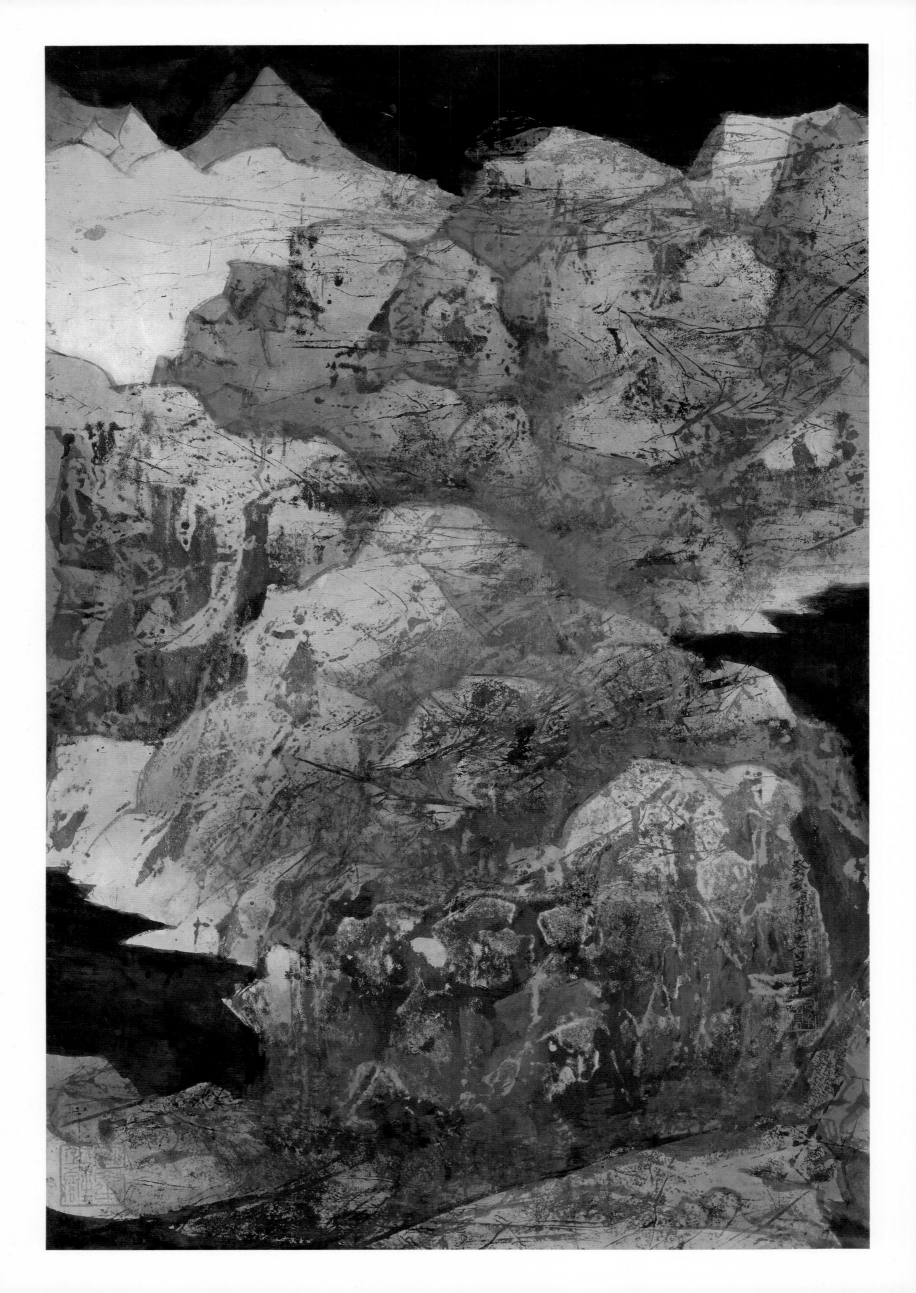

C.C.WANG
LANDSCAPE PAINTINGS

INTRODUCTION BY
JAMES CAHILL

Distributed by the University of Washington Press, Seattle and London

Published by Hsi An T'ang in 1986

Art Director: Yien-koo Wang
Designer: Rosanne Chan
Color Separation by Goody Color Separation (Scanner) Ltd.
Produced by Millennia Limited, Box 20631, Hennessy Road Post Office, Hong Kong

Library of Congress Catalog Number 86-72471

ISBN 0-295-96471-5 (clothbound)
ISBN 0-295 96472-3 (paperbound)

Frontispiece: Landscape #465, dated 1983, 61 × 39.5 cm, Artist's Collection

Contents

Dedicated to Yüan-su

Foreword

Since the age of fourteen I have been painting and observing nature, and for almost as many years I have been collecting and studying fine examples of painting, calligraphy, sculpture and the minor arts. The wealth of visual experience absorbed over a life-time has enabled me to create the landscape paintings — these ''mountains of the mind'' — which are reproduced in this volume. My basic desire in bringing these works together is to share my enjoyment of art, especially of painting, with my friends, colleagues and students, and with all who love painting.

Pictorial expression is the focal point for the viewer who embarks on an exploration of the world encompassed in these paintings, a journey along which are many changes of scene. Some of these have been as astonishing to me as they may be to the viewer. Indeed, I am never sure in which direction the next stage of development will propel me. At this point in my life, almost 80 years of age, I find myself painting more than ever, constantly renewing myself and continuing to grow as an artist. Creation has become a source of wonder to me.

Dr. James Cahill has known me since my arrival in the United States in 1949, and our discussions of Chinese painting have taken place intermittently over several decades. It is my good fortune that a fine scholar such as Dr. Cahill should appreciate my own paintings as well and has contributed an introduction to the volume. To Dr. Kao Mayching I convey my special thanks for her generosity, both in time and effort, in translating the introduction into Chinese. I am happy to draw upon the talents of my daughter, Yien-koo, to formulate the concept of the book and organize the minutiae for me as she understands my requirements and preferences. The interest of my granddaughter, Lynn King, in Chinese seals has resulted in a thoughtful essay on the little researched subject of the relationship between seals and Chinese painting.

I would like to thank Peter Neaman, who took most of the transparencies, and my old friend, Otto Nelson, who has always provided me with quality photographs whenever I needed them. My thanks also to Mr. Chiu Lim.

The publication of a book marks the end of its production; henceforth it is the readers who, through usage, give it life. I wish to thank all readers who will make this book come alive.

C.C. Wang

序

吾自十四歲始、鑽研繪事，探索自然。吾之鑑藏書畫、雕刻及工藝名品，亦肇於其時。平生狀觀、奔赴筆下，胸中丘壑，具象成形。今得結集刊行，吾之夙願遂矣。蓋高山流水，有待鍾期之賞，藝海歸航，樂莫大於與眾共享吾之所獲也。

竊謂畫意云者，乃觀者由其所見之象，妙契於心。其竦吾靈府者，當亦竦動觀者之心目。情隨境發，變化無方，吾固無以知吾胸中他日現何丘壑，僅知吾以八十之年，唯勤可寶。日新吾德、窮吾生於繪事，究創造之神奇而已矣。

吾自一九四九年寓美即與高居翰博士相契，數十年來於中國繪畫問題往復切磋，今復蒙其惠賜鴻文，溢美有如，不勝欣幸銘感之至。又承高美慶博士撥冗中譯，謹此致謝。是書之成，尚賴小女嫻歌之構思籌劃。外孫女金瑞玲玲夙好印章藝術，進而覃深於前人未探之域，寫成印章與中國繪畫之關係一文。此外，荷蒙彼得・聶曼先生拍攝影圖，摯友奧圖・納爾遜先生多年來提供優質照片，又林堯先生多方協力，併此敬致謝忱。

是書面世之日，亦即製作完成之時。而是書之生命，亦賴讀者之欣賞而生色。由是，則固應向愛護吾書之讀者磬折申謝也。

王己千

Wang Chi-Ch'ien and His Landscape Painting

Wang Chi-ch'ien in Recent Chinese Painting

To write an essay on Wang Chi-ch'ien is to write about Chinese painting in the second half of the 20th century. Saying that is not saying only that he is one of its central figures, as of course he is. It is also recognizing that he represents, perhaps more than any other living Chinese painter, the achievements of "traditional" Chinese painting today, and also the problems it must face and resolve in its relationship to its past and to the contemporary world. We can begin by observing that no Chinese artist now active has dealt with those problems more consciously or more effectively than Wang Chi-ch'ien.

I should begin also with a disclaimer: I am not a critic of contemporary Chinese painting, and could not write as one even if I chose to. I write as an art historian deeply committed to the tradition as it has come down to us over the centuries, and concerned about how it is to adapt and survive in our time, which must seem in many ways uncongenial to it. One need not feel apologetic about taking this historical view in writing about Wang Chi-ch'ien, since his awareness of his place in the tradition is crucial to his thought and his paintings. It is partly in tribute to him, then, that I want to try to construct an art-historical framework around his painting before considering it in itself.

Chinese painting today reflects the central problem of contemporary Chinese culture as a whole: how much of it is really viable in our world, adaptable and useful to present-day circumstances and sensibilities? Examples are plentiful to prove that holding on to the past for the sake of holding on is stultifying. Leading diametrically away from this wrong road is another, equally wrong if one is determined to preserve one's Chinese identity: letting go altogether, merging with the "international mainstream" (decidedly a muddied and disorienting current these days), relinquishing the sustenance of one's cultural heritage. How can artists remain Chinese without forfeiting their status as 20th-century artists, and at the same time be truly of the 20th century without compromising their independence and originality? The question may sound somewhat artificial, but it is one that troubles Chinese artists today. Many of them, living in China, Hong Kong, Taiwan, the United States, and elsewhere, have found personal solutions to this dilemma, solutions ranging in efficacy from barely workable to brilliant.

Among these, Wang Chi-ch'ien stands out as notably successful. He has retained a firm, even tenacious (because consciously sustained) hold on what he and other Chinese critics and connoisseurs have for centuries taken to be the main lineage in Chinese landscape painting: the lineage that is represented in the 17th century by Tung Ch'i-ch'ang and the so-called Four Wangs, the lineage whose earlier periods Tung himself designated as the "Southern School," and that became, after his time, the Orthodox School.

One might wonder, initially, how adherence to that school could be sustaining, since it can be argued (as I myself have done on numerous occasions) that most of its vitality had drained away by the mid-18th century, leaving little life to inspire the 19th- and early 20th-century practitioners of it. How, then, can anything satisfying and artistically significant be made of it at this late date? The question is a real one, since Wang Chi-ch'ien's paintings demonstrate that the Orthodox lineage of landscape, enriched with elements from other sources, *can* be the basis for highly original achievements in landscape painting. The question can be answered in two ways, by seeing Wang's achievement as part of a larger revitalization of landscape in the 20th century, and by seeing it as individual accomplishment. Both answers are true.

Until recent times, the expanding and enriching of an artist's style beyond the limits of what he received from his master was accomplished sometimes through the study of nature, but more often through the study of old paintings. Old paintings, however, were in private collections — there were no museums — and accessible only to those who, by birth or talent, had entrée to the great houses that owned them. It was a situation that tended to discourage stylistic explorations among those lacking such entrée. Those who had access to collections, on the other hand, were likely to belong to the scholar-amateur group of artists, people who had the right social standing; and they were too often constrained by technical limitations, and by the admonitions of theorists, from venturing outside a narrow range of "approved" styles and subjects. In the 20th century the constraints on Chinese artists loosened, and a broader familiarity with old painting, as well as with different currents in contemporary painting, became easier: through photographs and good reproductions, through museums and exhibitions, through increased opportunities for travel. At best, these factors brought new vigor and diversity to the painting tradition; at worst, they fragmented or diluted it, or opened the way to enervating kinds of eclecticism — one thinks, for instance, of the late P'u Hsin-yü.

As part of this general phenomenon of stylistic broadening and interaction, and the breaking of school boundaries, the Orthodox landscape tradition of the Four Wangs and their 20th-century followers have received enlivening infusions from the ideas and styles of the Individualist masters who were the Wangs' 17th-century contemporaries and opponents: Shih-t'ao and Chu Ta, K'un-ts'an, Kung Hsien, and others. What had then seemed irreconcilable oppositions in the basic approach to painting, to nature, and to the past, with each side firing critical salvos at the other, turn out now to be mutually enhancing in the works of some 20th-century artists who have managed to ameliorate the Orthodox style's narrowness of expression and relax its disciplines by adopting some of the untraditional and liberating practices of the Individualists. These artists — who are, as a group, the most interesting of the recent Chinese landscapists — have also been affected by the naturalism of Sung painting, as the Four Wangs scarcely were, and have thus become, in their paintings, more deeply responsive to their experiences of nature. Huang Pin-hung, beginning from a thoroughly Orthodox base, borrowed from K'un-ts'an, and from Ch'eng Sui and other masters of his native Anhui; Fu Pao-shih, never quite so orthodox, learned from Shih-t'ao and others. The orthodox-trained Tseng Yu-ho, in some of her works, was clearly affected by Kung Hsien. Wang Chi-ch'ien stayed close to the Orthodox School models in his paintings longer than these others; when he began finally to break away from them, in a way entirely his own, the Individualist master contributed heavily also to his emancipation. His may well prove in the end to have been the most successful synthesis, preserving more of the strengths of his Orthodox heritage while accomplishing striking transformations of it.

An achievement of this kind depends not only on individual artistic creativity — although, of course, that is the factor that ultimately accounts for the heights it reaches — but also on the particular background of the artist. Wang would be the first to insist that his training and experiences in early years were crucial in the formation of his style, and we had best sketch them in before turning to his paintings.

The Development of the Artist

Wang Chi-ch'ien was born in 1907 in Suchou, a city that in the Yüan and Ming dynasties had produced or harbored more painters than any other in China. Suchou's pre-eminence as an artistic center had given way, from the 17th century on, to a succession of others — Sungchiang, Nanking, Yangchou, Shanghai — but the old cultural aura never entirely dispersed, and still has not. Wang's ancestry does not, as might seem appropriate, include any of the Four Wangs of the Orthodox School; among painters, he claims only Wang Wu, a specialist in flowers, for a family predecessor. But the Ming grand secretary Wang Ao (1450-1524), who was also a famous calligrapher and collector, was his fourteenth-generation ancestor, and his grandfather was a high official under the Ch'ing. His background urged him, then, toward scholarship and politics. But it also exposed him to a family collection of paintings, and an environment in which artistic talent was valued. Wang's strong inclination from childhood was to become an artist. He studied painting from the age of fourteen from a teacher in Suchou, and later from Ku Ling-shih, whose family collection was the great Kuo-yün-lou, "Passing Cloud Tower." From this time Wang joined a tradition within which connoisseurship of old paintings and creation of new ones were all but inseparable activities.

In the 1930s, in Shanghai, Wang became a disciple of Wu Hu-fan, central figure in the distinguished circle of collectors, scholars, and artists that has produced, apart from Wu himself, most of the leading connoisseurs of this century: the late Chang Ts'ung-yü, Hsü Pang-ta in Peking, Hsieh Chih-liu in Shanghai, and Wang himself. The critical standards of these men and the depth of their understanding, especially of paintings of the Yüan and later periods, were unmatched, and were also brought to bear on the paintings that they did themselves. The others in the group, perhaps because they remained in China, have remained more conservative in their styles and tastes — Hsü Pang-ta has even admitted that he fails to understand Wang Chi-ch'ien's recent paintings! Wang went to the United States where he began a new chapter in his life and a new phase in his development as an artist.

This was in 1949. Wang has lived mostly in New York since then, but spends time also in San Francisco, a city which he especially enjoys; he has given courses on painting and connoisseurship both at the Chinese Culture Center there and at the University of California in Berkeley. He travels frequently to Japan, Taiwan, Hong Kong, and recently China, to see exhibitions and collections of paintings and to expand his knowledge of Chinese painting. A great many paintings formerly in his possession are now prominent in the holdings of American museums; in this way alone, Wang has

benefitted immensely the appreciation of Chinese painting in the United States. But for many of us who count him among our teachers he has also served to represent for us, and to transmit to us, the great tradition of Chinese connoisseurship: unable to meet Tung Ch'i-ch'ang, we are happy to have known and learned from C.C. Wang.

For a few years after his move to the United States, Wang continued to paint landscapes which, while strong and admirable, stayed safely within the familiar tradition. A brief period of experimenting with painting in oils, in the early 1950s, failed to give birth to the cross-cultural Great Synthesis, the emergence of a Chinese successor to Cézanne, that he had apparently hoped for, and he wisely gave it up. But the experiment was not fruitless: after this he began to use color in ways for which orthodox Chinese practice provided no precedent, and to expand as well his ways of using the brush and applying the ink and color without, he would insist, sacrificing the strength of brushwork that he still regards as the firm foundation of his painting. By the early 1960s Wang had created a style as distinctive, and as essentially emancipated from old models, as the styles of the 17th-century Individualists, from whom, nonetheless, it continued to draw inspiration, as it did also from whatever elements of the Orthodox style still seemed useful. Some qualities of Sung landscape painting, moreover, which the Orthodox masters had scarcely understood even when they claimed to be imitating it, began to appear in his works: looming mountains made monumental by the diminutive scale of houses and trees; evocative renderings of mass and space, light and shadow and mist. Brushwork loosened, becoming broader and dryer or wetter, taking on a more improvisatory look.

Then, later in the 1960s, Wang's style underwent a more radical change. He began to use random techniques — crumpling the paper and imprinting it with ink, spattering, sponging — as a basis and inspiration for his compositions. The semi-random configurations produced in these ways were turned into powerful mountain landscape images through the addition of contour drawing, washes, details. Even this technique was not without Chinese precedent: similar devices had been used by artists as early as the 8th century, anticipating by about a millennium the British artist Alexander Cozens's technique of beginning with semi-random sponge-marks of ink. But for some of Wang's admirers, who had thought of him as the very guardian of orthodox brushwork in our time, the shock was like that felt by Stravinsky's followers when, late in life, he abandoned the diatonic scale for the serial mode of composition: if the Old Master has swerved from the True Path, they felt, what remained of tradition?

Wang himself, on the other hand, continues to argue that this, too, is a kind of "good brushwork," so that he has not swerved at all, and the tradition is preserved more or less intact. The seeming contradiction is important, and we had best attempt to resolve it.

Semi-Random Configurations as "Brushwork"

The evolution of the Orthodox School style of landscape in the 17th century was a process of renunciation as much as creation, and among the capacities of painting that were renounced, or at least strongly de-emphasized, were calligraphic gesture and accident. All stages in the act of painting must be under total control: in a typical landscape by Wang Shih-min or Wang Chien, every brushstroke seems pre-determined, in place. Wang Chi-ch'ien's work, in contrast to those of many other contemporary artists, continues on the whole to observe the stricture against calligraphic gesture — the few paintings in which he has let his brush run loose are not, for the most part, among his most successful. But he does not observe the other stricture, the one against accidental or semi-random forms; on the contrary, he has made it the basis for a new style. In what sense can the crumpled-paper textures and other forms of this new style be considered brushwork at all, least of all *good* brushwork?

If we were to try to isolate the quality most treasured by connoisseurs of Wang's group in the paintings they most admire — the landscapes of the great Yüan masters such as Huang Kung-wang, Ni Tsan, and others, of Tung Ch'i-ch'ang, of Wang Yüan-ch'i — we would find it not so much in the strength or beauty or interest of individual strokes, or even of assemblages of individual strokes, although those qualities can also be admired, as in the all-over richness and randomness of texture achieved in a fabric of varied brushstrokes which can be described as variety in consistency, order in the seemingly uncontrolled. The brushwork of these artists at their best appears to follow no simple system or set of rules, other than the general ones of utilizing the full range from light to dark in value, from wet to dry in substance, and of avoiding perceptible pattern. (When an artist of the group

such as Wang Hui falls into repetitiousness, as in the insistent rows of horizontal dots of his late style, this is recognized as a weakness.) The effect they pursue in this seemingly unsystematic way is a quality of *naturalness*; the forms of their landscapes escape the artificiality of lesser artists' efforts by looking unplanned, innocent of human intent, like a passage of unspoiled natural scenery. It is an effect beyond skill, belonging in the realm of style that the Chinese sometimes term "awkward" in a positive sense (Wang Chi-ch'ien prefers "primitive" or "naïve.") The Chinese word *ts'ang* 蒼, so often used in Chinese writings about this kind of painting and so perplexing for translators of these writings (the dictionary definitions are "green, luxuriant, hoary, old") refers, I think, to just this quality. (Edward Schafer's *First Supplement* to Mathews' *Chinese-English Dictionary* offers "gray-green, grizzled," and Schafer has explained the term as combining color and texture, referring to the appearance of a field of grass.)

The brushwork that Wang Chi-ch'ien learned as his "basic training" in Chinese painting and used in his early works, and which he can still use when he chooses to, is of this kind. For his more recent landscapes, however, he has discovered that a quite similar effect — perhaps, he would argue, *more* natural, *more* free of human manipulation, while no less visually absorbing — can be produced through the techniques he now employs. The semi-random configurations and textures achieved in this way can be recognized as representing an equivalent to good brushwork. When combined with the compositional control that Wang always exercises, they strengthen and enrich his paintings. These new processes for applying ink-textures can also inspire new compositions that avoid the school stereotypes. The whole effect is of freshness, spontaneity, and a new kind of naturalism. Far from being a reductive technique, it functions as a transcendental one.

A key to this naturalism and evocativeness is the successful reconciliation of the effect of *spontaneity* with the effect of *order*. An unplanned order may seem an anomaly to us, who tend to think of order as the outcome of an ordering will or intelligence, but it is a concept basic to Chinese cosmology and Chinese painting theory. Naturalism in Chinese painting implies more than randomness or the avoidance of planned-looking forms; it implies also a sense of inherent order — not one that is immediately perceptible, made up of easily-recognizable patterns and repeated forms, but one that gives the forms and their arrangements a mysterious rightness. The Chinese term for this natural order, or rightness, is *li* 理, a word often rendered as "principle." The graph for the word suggests its etymological origin: it meant originally the inner pattern of organization, or infrastructure, of a piece of jade. (It was, of course, the old Chinese jade that was meant, the stone known as nephrite, with its rich range of colorings and markings, not the more glassy green jadeite used in modern times for jewelry.) The outer markings of the jade could be read as revealing this inner structure; outer configurations, that is, were subtle indicators of inner nature. An essential characteristic of natural objects — rocks, trees, clouds, hillsides — was that their visible surface configurations allowed the perceptive observer, through an understanding both intuitive and acquired, to read the underlying order of his world. Painting, in its highest manifestations, could provide its viewers with understanding of a similar kind. But this required that the artist not only possess great skill and the grasp of phenomena that comes from stored experiences, but also that he be able to create as nature does, infusing spontaneity with an unwilled kind of formal organization. That achievement underlies the success of such painters as K'un-ts'an and Shih-t'ao in the 17th century, and the failure of it accounts for the thinness and weakness of so much landscape painting since then. Wang Chi-ch'ien is one of the relatively few Chinese artists in our century who have engaged themselves seriously at all with this problem, and the best of his recent paintings represent triumphant solutions to it.

Wang Chi-ch'ien's Recent Paintings

We have been talking about techniques, and textures, and considerations of art history; what about the paintings as images?

Wang Chi-ch'ien himself regards the imprinting that provides textural substance to the paintings as like the instrumental accompaniment to a song; what he adds with the brush provides the lyrical element, the song. Tung Ch'i-ch'ang, he maintains, in his obstinate abstractions, lacks this element of musical accompaniment, while many Western painters who refuse even to strive for it achieve nothing but "noise."

Noise or accompaniment, the patterns of ink printed on the paper by Wang at an early stage in the painting process are only suggestive; it would be difficult to say that in themselves they resemble or represent rocks and mountains. They might be considered metaphorically as nature's part in a collaboration, with

the artist's part coming after, but such a formulation would over-stress the separation: it is really the artist who does the imprinting, and nature, or a half-conscious recollection of it, which guides his hand in the brush-painting that makes these "natural markings" into images of landscape. The conception and visualization of the landscape, its grandeur, spaciousness, and scale, are imparted in this later stage; streaks and smudges of ink become gigantic boulders or groves of bare trees, ravines and rivers appear in the dark areas of wet ink and the light streaks that separate them. Dense forests are made to grow along the mountaintops or in the valleys below, softening the rocky masses; clusters of houses and villages are located beneath awesome cliffs, inviting the viewer to imagine how living in such a place would alter one's consciousness. Beginning with an assemblage of tactile matter, Wang creates a conceptual structure around it, recapitulating the process of creation in Chinese cosmology within which amorphous collections of ch'i 氣, ether or matter-energy, coalesce into palpable forms in harmony with li, the natural order. Wang thus turns the markings that are clues to the structure of the world into complete and coherent worlds. The pleasure of the artist in seeing these worlds takes form before his eyes, and beneath his hand, can only be imagined by us who are not artists; but the paintings themselves reveal enough about how they came into being to allow us to participate empathically in their creation.

Wang Chi-ch'ien's paintings could not always be described in such terms. Most of his landscapes of the 1950s seemed to many of us too controlled, too tied to tradition; some of his paintings of the 1970s seemed, by contrast, to rely more on random patterning, to relinquish more the strengths of technical control and representation, than we were comfortable with. Most of his new paintings strike nice balances between these extremes, presenting the purely visual pleasures of abstract form and texture but allowing us imagined entries into sublime scenery.

Using the word "scenery" should introduce a note of caution in anyone who has talked with Wang Chi-ch'ien, since he has often used the word pejoratively, in his favorite analogy of painting and opera, which he uses to explain the importance of brushwork in Chinese painting. Brushwork, he says, is like the voices of the singers in opera, which are what the opera-goer really wants to hear; "scenery," the representational aspect of the painting, is like the story, which the opera-goer knows before he arrives at the theater. The analogy is enlightening but inexact, both because opera-lovers today must in fact be caught up in the dramatic force of the opera if it is to succeed, and because "scenery" is more fundamental to the experience of the best Chinese painting, including his own, than he chooses to admit when he is emphasizing brushwork. Whatever their means of facture, his best paintings impress us ultimately as grand visions of nature, in which awesome mountains of mysterious shape loom over the lesser, almost incidental intrusions of human dwellings. These are, in the end, pictures, and powerful ones.

In his most recent paintings Wang has tended to soften the firm contours of his landscapes of the 1970s, and to make greater use of color, sometimes heavy mineral pigments. Forests may stand out now in brilliant blues or autumn reds, and flights of white birds may pass across the dark mountainsides. Some other Chinese artists working in China and elsewhere have also experimented recently with adding heavy color to landscapes, but in this as in other respects, Wang is no imitator of current trends; his innovations are personal, parts of a consistent development, one that has never slipped into simple repetition of a formula, however successful and popular it might have become.

Returning finally to the art historian's concerns, we can note that in this refusal to stand still, Wang Chi-ch'ien also stands apart from an unhappy tendency in too many recent Chinese painters to arrive at a personal style and then relax comfortably into the security it offers, replicating their own successes until they become formulaic. One could trace that fault in the recent history of Chinese painting at least back to the early Ch'ing period, when even major artists such as Wang Hui seemed to come to the end of their creative phases long before they gave up painting. For an artist who is, as Wang Chi-ch'ien is, in his late seventies to continue his creative growth in this way is admirable even apart from the continuing high quality and deeply satisfying nature of the late works in themselves. We can only rejoice, and wish Wang many more active and productive years, and even more transcendental achievements in his paintings. No one but the artist himself can anticipate what these will be. Perhaps even he cannot anticipate these, but they are sure to be rewarding.

James Cahill
August, 1985

王己千及其山水畫

王己千與現代中國繪畫史

撰文討論王己千的藝術，猶如撰寫二十世紀下半葉中國繪畫發展史。我這樣說，不僅因爲王氏是這個時期的中流砥柱，同時也因他代表今日傳統中國繪畫成就的崇高地位。當今中國畫家中，相信沒有比他更透澈地領悟到繼承傳統及開創現代所要面對的種種迫切問題，進而有意識地逐步解決這些問題。

先此聲明，我並非現代中國繪畫的評論家——在這方面我實在有心無力。撰寫此文，乃因我身爲中國繪畫史研究者，在致力研究這源遠流長的傳統的時候，也關注這傳統能否適應現代的需求而延續下去。其實，從歷史的角度來介紹王己千，是很恰當的，因爲他的思想及創作，無不體現了他對自己在傳統中的位置的反省，所以，我在討論他的作品之前，先建立一個美術史的架構，實可視爲對王氏的敬禮。

現代中國繪畫頗具代表性地反映了當代中國文化的困境。中國文化中，何者能適應現代世界？何者能在現代生活中應用？又有那些足以表達現代人的感情？如果單爲維護傳統而抱殘守缺，必使傳統全面僵死。此種例子屢見不鮮。而與盲目堅持民族傳統同樣錯誤的的另一極端，便是全面放棄，截斷民化遺產的補給，在國際文化的主流中，隨波逐浪，甚至無視現今的國際主流本身已是極其混亂，無所依歸。到底中國的藝術家，怎樣才能保存民族的特性，旣不放棄獨立與創新，亦無愧於二十世紀的時代？這些問題似乎很空泛，但却眞實地困擾着現代中國藝術家。他們散居中國、台灣、香港、美國等地，各自探索化解這矛盾的方案，成效亦各有高下。

在這些畫家當中，王己千的成就是有目共覩的。他繼承了中國繪畫中佔有主流地位的道統，與十七世紀的董其昌及四王一脈相承。這就是由董其昌所倡導而後來被奉爲畫壇正宗的“南宗”系譜。但是，如所周知，這所謂正統主流的畫風，至十八世紀中期經已沉滯不前，不足以啓導清末民初的畫家，又豈足以讓當代畫家從中汲取養料？即使眞有所得，又是否具備一定的藝術義意？這些質詢是無法迴避的。可是王氏的創作，清楚的說明了正宗派的山水，在融匯了新的元素後，仍足以成爲深具獨創性的山水畫的基礎。這種情況，一方面可以解釋爲二十世紀山水畫復興的一個重要環節，另一方面當然是王氏個人的成就，而這兩種說法均能成立。

古代畫家欲在本師之外，別開蹊徑，不外取法自然及研習古人名蹟，尤以後者爲要。然而古代中國並無博物館，古畫均屬私人所有；除非因深厚交誼或才華備受賞識，一般畫家不易摩玩眞蹟。這種情況，顯然不利於新技法及新風格的開拓。至於有緣觀賞眞蹟的畫家，多出身於士人階層，書畫創作仍屬案牘之餘的墨戲。他們受技巧的限制，在風格及題材方面也不輕易偏離畫論家所規劃的正途。及至二十世紀，這些局限逐步解除。因現代印刷術的發達，博物館及展覽會的開設和國際交通的便利，不僅增加畫家對古代繪畫學習的機會，也使他們接觸到當代的各種潮流。從好的一面來看，是給繪畫傳統注入了新的活力，產生多元化的發展。但從壞的一面看來，却割裂及冲淡了中國繪畫傳統，甚至促成了一種虛弱的折衷主義。已故的溥心畬即是一個例子。

今天這多種風格相互影響的局面，打破了畫派之間的界限，使四王正宗畫派的現代繼承者，不必囿於一家一派，甚至可以融匯與四王對立的個性派如石濤、朱耷、髡殘、龔賢等人的思想及風格，從而獲得新的刺激。對繪畫創作、師法自然與師法古人的基本態度，過去曾經有勢不兩立的看法；而在今天畫家的筆下，可以兼收並蓄。他們對明末清初具獨創性的畫家的學習，革新了正統畫派表現範疇偏狹的弊端，而正統派嚴謹的筆法，也因融入豪放恣縱的畫風而呈現較豐富的變化。除此之外，他們還吸納過往不受四王重視的宋代繪畫的寫實精神，因此他們的山水畫中，體現了更深刻的對自然的感受。舉例來說，黃賓虹在純粹的正統畫派的基礎上，取法髡殘、程邃及其他新安畫派大家。傅抱石雖然算不上正統派的一份子，也學習石濤等人的畫法。曾受正統派嚴格訓練的曾佑和，她有些作品明顯地受到龔賢的影響。王己千較諸以上各家，是忠於傳統典範最持久的一位，但當他終於另闢蹊徑時，明末清初深具獨創精神的畫家也發揮了決定性的作用。他所經營的方案與別不同，在蛻變中保持了較多正統畫派的優點，因此，也可以說是最成功的。他的成就，當然來自畫家個人藝術創造的心靈，但與他獨特的背景也有一定的關係。王己千就曾指出自己早年的訓練及閱歷，對他風格的形式，具決定性的影響。讓我們先來回顧他的生平，才來討論他的作品。

畫家的成長

王己千於一九○七年生於蘇州。蘇州畫壇在元明兩朝，名家輩出，冠於全國。十七世紀以後，其畫壇領導的地位，雖然逐步被其他城市所取代，繪畫中心轉移到松江、南京、揚州和上海，而此地風流未沫，至於今日。在家世方面，王己千與四王並無淵源，這點倒令人覺得意外。其先人擅畫者僅得王武（1632—1690），為清初花鳥畫家。而王鏊（1450—1524），明代戶部尚書兼名書法家及鑑藏家，則是他的十四世祖。他的祖父是清朝顯宦。由此可見，他的家庭背景促使他鑽研學問、關心政事，同時，也為他提供重視藝術熏陶的環境及親炙家藏書畫的機會。

王己千自幼即有志於繪事，十四歲起便追隨一位蘇州畫家習畫。其後轉入蘇州名家顧麟士（1865—1933）門下，亦因而飽覽顧氏祖傳的《過雲樓》珍藏。觀摩古畫及揮毫創作的互相配合，在中國早有悠久的歷史。從這時開始，王己千便成為這傳統的一員。

三十年代在上海，王氏成為吳湖帆（1894—1968）的高足。吳湖帆是譽滿滬江的書畫名家，精於鑑別，收藏尤富，在及門親炙的收藏家、學者和畫家中，更孕育出一批傑出的鑑賞家，包括北京的張葱玉、徐邦達和上海的謝稚柳，當然王己千亦在其中。他們鑑賞之精湛，對元代以來繪畫認識之深，在當世堪稱無與倫比，而鑑藏的識見對他們自己的創作也產生一定的影響。目前居國內的幾位，其風格及意趣均較保守，徐邦達甚至坦然承認無法理解王己千的近作。王氏則於一九四九年離華居美，因而在生活上及藝術上，均展開新的一頁。

在美三十餘年，王氏以紐約為家，亦時往其所喜愛的三藩市小住。他曾為三藩市的中華文化中心及伯克萊加州大學講授中國繪畫及鑑賞課程。其遊踪亦常遠及日本、台灣、香港以至近年來的中國，參觀展覽會及公私珍藏，以增廣對中國繪畫的見識。美國各大博物館中不乏他的舊藏，僅此即已可見王氏對中國繪畫在美國之研究及欣賞惠益不淺。他是我們尊敬的老師，不僅象徵了中國書畫鑑賞的偉大傳統，也傳授給我們這方面的學養。我們雖然無緣與董其昌相會，但得到王己千為師，也是令人欣喜的事。

王氏移居美國初期，仍格守山水畫的傳統，展示其精湛的造詣。在五十年代之初，他一度嘗試油畫創作，有志成為塞尚的中國傳人。然而此一構建中西文化融合之"大成"的理想未能如願，他終於明智地放棄。但是這些試驗並非徒勞無功。自此之後，他在運用色彩的大膽創新，實為正統畫派所未見，而且在無損中國筆墨精粹的大前題下，開拓運筆、用墨及設色的新技法。及至六十年代初期，王己千經已奠定其獨特的畫風，一方面保存正統派的精華，同時也汲取明清之際個性至上的畫家的創造精神，並以他們為典範，擺脫古人的桎梏。此外，正統派大師雖倣傚宋人而其實不明其所以然，但王己千卻在其畫面上靈活地運用宋畫的一些元素，如於崇山峻嶺中綴以棲台樹木，從空間比例中突顯雄偉的氣勢，充份表現虛實疏密的層次和煙靄晦明的效果，而筆墨酣暢，乾濕並用，尤見興會淋漓。

及至六十年代後期，王氏的畫風再起劇變。他採用了偶然性的技法，諸如拓印法、潑灑法、海棉揩抹法等，作為他構圖的根據及啟示。始則隨意塗抹，任其成形，繼而用筆略加外廓及渲染，並補充細節，即構成其獨特的新風貌。這種技法，可追溯至唐代，因此是有先例可援的。這比英國亞歷山大‧哥臣斯類似的技法早出近一千年。但是，對於一向推許王己千為今日傳統正宗筆墨守衛者的人，所受的震撼，相信只有史特拉汶斯基從全音階轉變到以十二音音列作曲所引起的反應才可以相比。連大師巨匠都背離"正道"，傳統還有立足之地嗎？

對王己千本人來說，他的新畫風仍是有筆有墨，不僅未曾離棄傳統，甚至相對地保存了它的完整性。此中似乎存着矛盾，我們須得提出解答。

隨意塗抹是否筆墨

十七世紀形成的正宗派山水畫，其發展根源於藝術創造，同時也有一定的排斥性。所排斥的就是"書法性"及偶然性。一幅畫從無到有，全部在嚴謹的技法控制之下。以王時敏及王鑑的典型風格為例，每一

筆均有軌迹可尋。因此，王己千的作品，一般來說較時人貶抑書法性的線條——而他用筆豪放的一些作品，較其上佳之作終遜一籌。然而王氏却不排拒偶然性的效果，甚至用來創建新畫風。究竟這些摺皺紙團拓印出來的紋理，以至新畫風中的其他元素，怎能稱爲“筆墨”，甚至是上佳的筆墨呢？

假如我們嘗試從王己千等鑑賞家最推崇的繪畫(例如黃公望、倪瓚、董其昌、王原祁等人的山水畫)，提取他們所重視的特質，當可發現這不在來自個別或叢集的線條本身的力量、美感或趣味(雖然這些也有值得欣賞的地方)，而在整體的豐富飽滿而揮灑自如的肌理，出之於變動不居的筆觸；萬變而不離其宗，從心所欲而不逾於規矩。在這些畫家的代表作中，顯然沒有簡單的成法可循，他們只是儘量發揮筆墨濃淡乾濕的效果，同時避免堆砌成明顯的格套(其中偶或使用重複的筆調，例如王翬晚年作品中橫點的排列，則當視爲不足取法的弊病)。這種無成法可循的創作觀念，所響往的就是自然的神韻。他們的山水畫，渾然天成。因此能避免平庸的畫家所犯的虛假堆砌的弊病。這種意趣，超乎技法而近於中國畫論中有時提到的“拙樸”的風格特質(王氏則稱之爲“原始”或“天眞”)。另一個中國畫論中常用來形容此類作品的字眼是“蒼”，極之不易英譯。字典釋之爲“青色、茂盛、年老”，正是此意(愛德華·薛弗之《麥氏漢英字典補編》則取其灰青、灰白之意，並解釋爲貌似於草而兼具顏色及質感的特性)。

王己千的基本訓練及早期作品所用者，均屬此類筆墨，至今仍然運用自如。但在近期的作品中採取的，却是王氏認爲更自然，更少斧鑿痕迹，而且同樣引人入勝的技法。由隨意塗抹所產生的造型及肌理，應可視爲等同於傳統所謂的有筆有墨，因爲二者殊途同歸。王氏以其新技法與其一貫的嚴謹構圖結合，使具作品更爲豐富充實，多彩多姿。這些任由水墨自然成形的新技法，且能啓發新穎的構圖，使畫家進一步脫離正統派的巢臼。作品的整體效果，清新生動而帶有新的自然主義的精神。因此，這些技法的價值，不僅在於其精簡凝煉，而在於能發揮提昇精神境界的作用。

此種自然主義的神韻和引人入勝的關鍵之處，乃在畫家取得即興和秩序兩種效果的協調。對西方人來說，秩序是意識及理智的結晶，所謂漫不經意的秩序，則似乎是不可思議的，但這却是中國的宇宙觀及繪畫理論的基本概念。中國畫的自然精神，絕不單在其隨意揮灑、不事經營，而實兼具內在的秩序。此種秩序當然非指一目了然的格式或不厭重複的造型，而是在造物賦形之際的一種行於所當行、止於所不可不止的神妙契合。自然的秩序，主國人稱之爲“理”。從字源探之，乃玉石的紋路。當然是指色澤紋理變化多端、屬於軟玉類的中國古玉，而非碧綠通透帶玻璃質，用於現代首飾的硬玉。外露於玉石的紋路，被視爲內在本質的呈顯，所謂有畜於中，才能形之於外。而自然界中的事物，包括山石、樹木、雲氣、幽壑，僅屬自然的表徵，須待有識之士以其慧心靈智，洞入深微，發潛質之幽光，然後物之形與理皆無所隱。繪畫的最高表現，即能使觀賞者同登此境。於此自須畫家首先具備高超的技法，從經驗的累積中掌握自然的表象，更須參透自然的造化，然後智止神行，不拘形象，妙造自然。明淸之際的髡殘、石濤等人的成功，乃因能妙臻此境，而其後的學步者，則未達其道，薄弱無足視。王己千是當代有數勇於探索這些問題的畫家之一，而他近期的佳作，足以證明他成功地找到了答案。

王己千的近作

我們已經討論過繪畫的技法、紋理和美術史的問題，至於繪畫作爲意象又如何呢？

王己千將畫面上拓印的紋理，比喻爲歌曲的伴奏樂器，而他用筆所加的則是曲詞。他認爲董其昌因執着於抽象的形式，使其作品欠缺了樂器伴奏，至於許多西方畫家則根本無意追尋，所得者不過是“噪音”而已。

無論是噪音還是伴奏，王己千在創作過程的第一階段，在紙上印下的水墨痕迹，僅是暗示性的，不知是山還是石。必要再經畫家加工，才能成畫。這象徵了自然與人的合作，先見自然之先功，再加人力。但是這樣的解釋只強調了主客體的分離。其實拓印仍需由畫家動手，其後用筆點染，乃畫家以其慧心，化自然的渾沌爲丘壑的形體，而其中當然少不了畫家體察自然的經驗。自然山川的陶鑄成形，

展其雄偉遼闊之姿，乃是創作過程後一階段所達成的。畫面中斑駁的墨痕，蛻變爲巨大的山石或疏林，丘壑見於淋漓的墨暈，而兩者之間的白線，即成河流。更綴茂林於嶺端谷底，乃使山石顯得柔和。而高崖矗立之下略添村落人家，亦使觀者得以想象生活於此自然境界中的新感受。王己千從可感觸的物象開始，昇華爲深具理念的結構，重現中國宇宙觀中自然而創造過程，將無形無朕的氣，轉化爲可見的形象，與自然律理和諧融合。換言之，王己千將暗示世界結構的墨痕，化爲完整而統一的世界。我輩並非畫家，僅能想像畫家得心應手，使心中的世界現於目前的樂趣。但每幅作品已呈現其創作過程，足使觀者寓目遊心，同參其創造的境界。

　　討論王己千的繪畫，不能一成不變。他五十年代的大部份作品，似乎過於嚴謹，太囿於傳統。相反地，七十年代的一些作品，則似乎過份依賴偶然性效果，因而忽略了精到的筆墨控馭及具象的世界。但是他近期的大部份作品，則已在這兩個極端中找到了巧妙的平衡，一方面具有足以引起純粹視覺趣味的抽象造型和肌理，另一方面也能使觀賞者馳騁其想像於雄偉壯麗的自然景物。

　　使用"景物"一詞，可能要謹愼一點，因爲王己千向來輕視此詞，尤其是用於以歌劇來譬喩筆墨在中國繪畫中的重要地位的時候。他認爲筆墨猶如歌劇中歌者的唱腔，也就是顧曲周郎的眞賞所在，而畫中具像的景物，則僅是歌劇的故事，歌迷在踏進劇院前早已耳熟能詳。我覺得他的比喩很有啓發性，却略嫌籠統，因爲今天的歌劇愛好者，要求一齣成功的歌劇，必得同時具有劇力萬鈞的劇本。正如在欣賞中國繪畫的過程中，"景物"仍是備受重視的基本要素。王己千雖然強調筆墨，而其作品實亦不廢景物的經營。歸根結柢，王氏的畫作，展現了宏偉壯闊的自然境域，尤其當此中的奇峰峻嶺，森然籠蓋於似若僅作陪襯的村落人家之際，一幅偉大的作品乃告完成。

　　在他最新的作品中，七十年代舊作那些規整的山巒輪廓已顯得較爲柔和，而色彩則至爲大胆創新。他用耀眼的靑綠或濃重的秋紅來突顯森林，飛翔的白鳥橫越暗黑的山坡。近日有不少中國畫家也在試驗於山水畫施以重彩，但一如過往，王己千並非追逐潮流。他的創新是獨具個性，有發展之迹可尋的。他從不簡單地重複公式，即使這公式廣受歡迎，極之成功。

　　最後歸結美術史研究者所關注的問題。王己千堅持不斷創新的道路，努力不懈，不像一些現代中國畫家，在建立個人風貌後，即耽於安樂，不斷自我重複，終陷於俗套。此弊在近代中國繪畫史上自淸初即已出現，大家如王翬的創新動力，似乎遠在他的繪畫生涯完結之前早已喪失。反觀王己千以近八十歲的高齡，創造力源源不竭，孜孜忘倦，近作尤能高屋建領，窮究自然。我們在欽仰欣忭之餘，尤望王氏續其豐產之年，創造超越的成績。除了王氏沒有人能預測以後的發展，可能連王氏本人也不知道，而可知的是，有一分耕耘，就有一分收獲。

高居翰著
高美慶譯

The Paintings

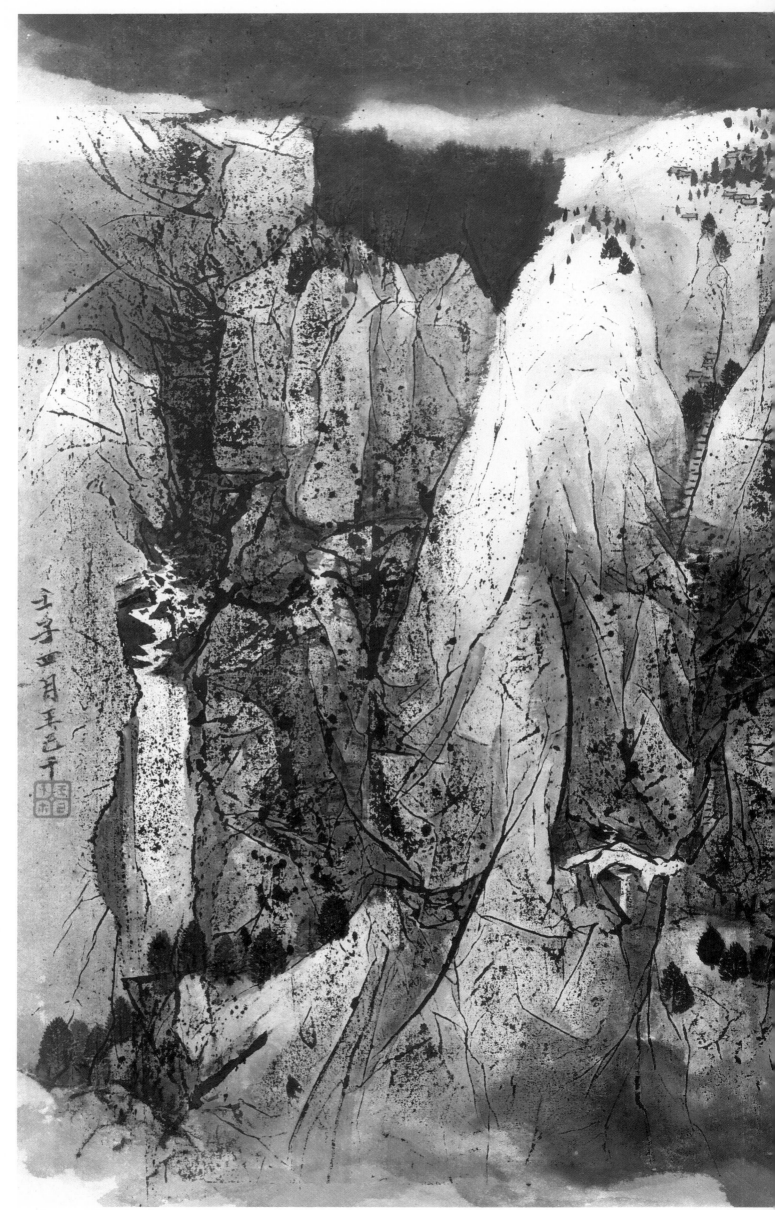

Landscape #150, dated 1972, 61 × 81.3 cm, Mr. and Mrs. Frank Cho Collection

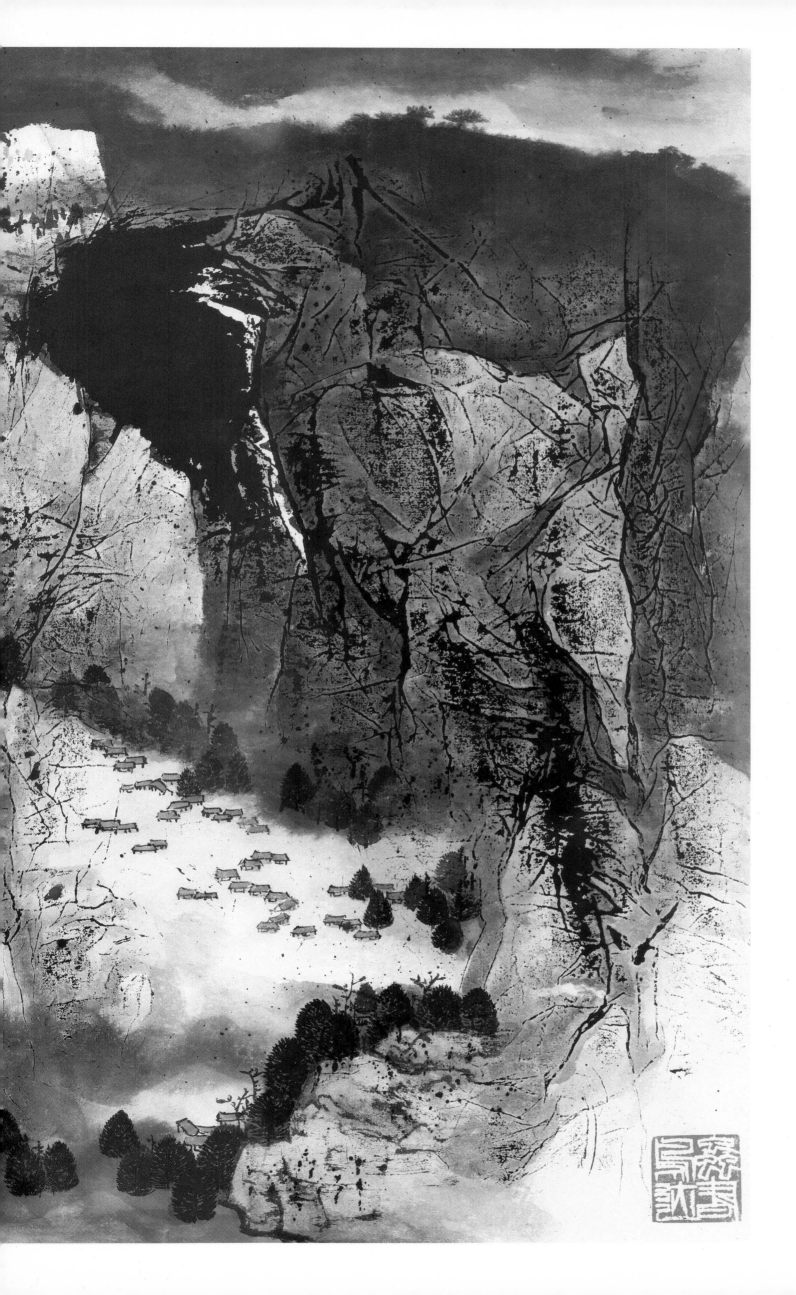

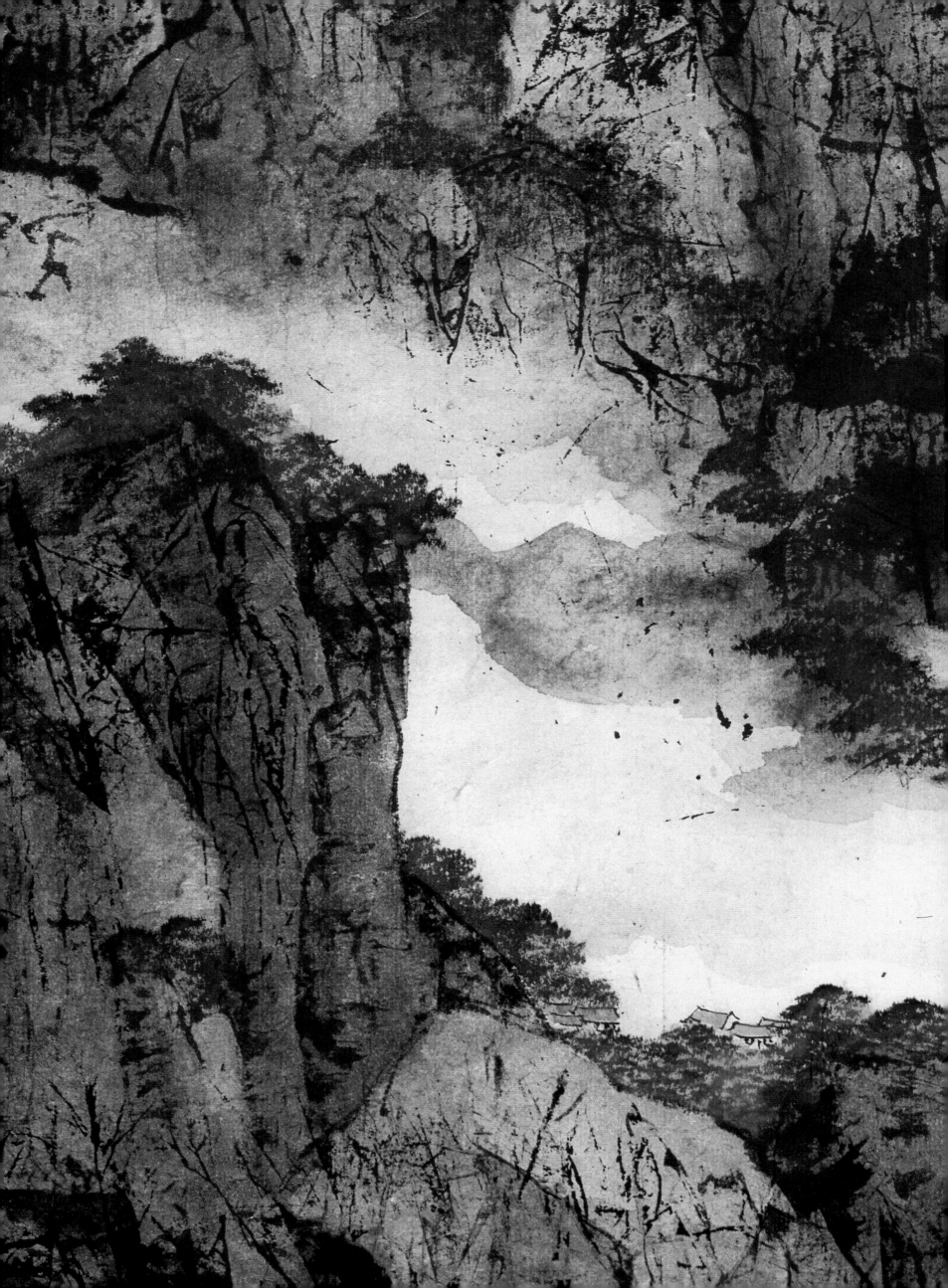

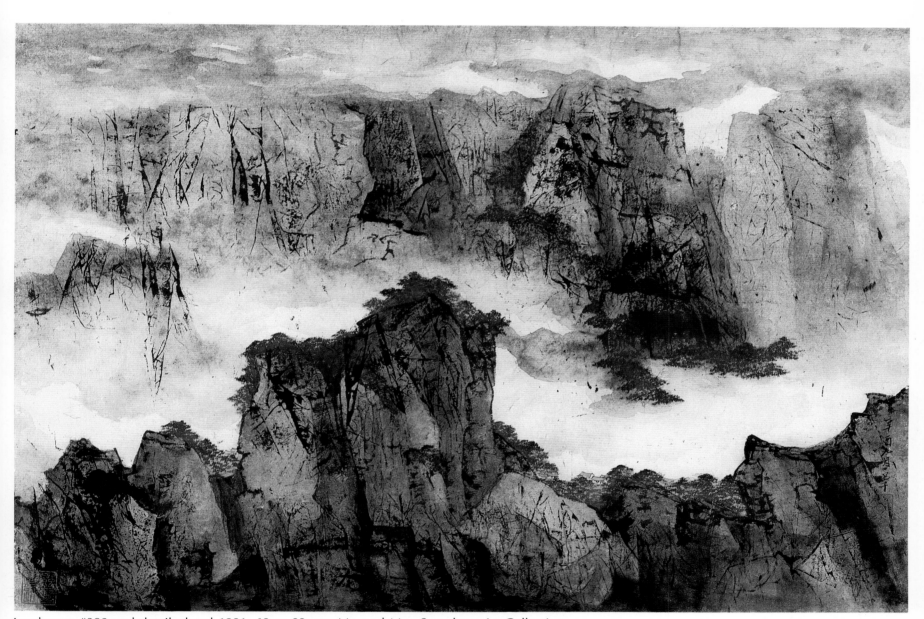

Landscape #392 and detail, dated 1981, 63 × 93 cm, Mr. and Mrs. Sun-chang Lo Collection

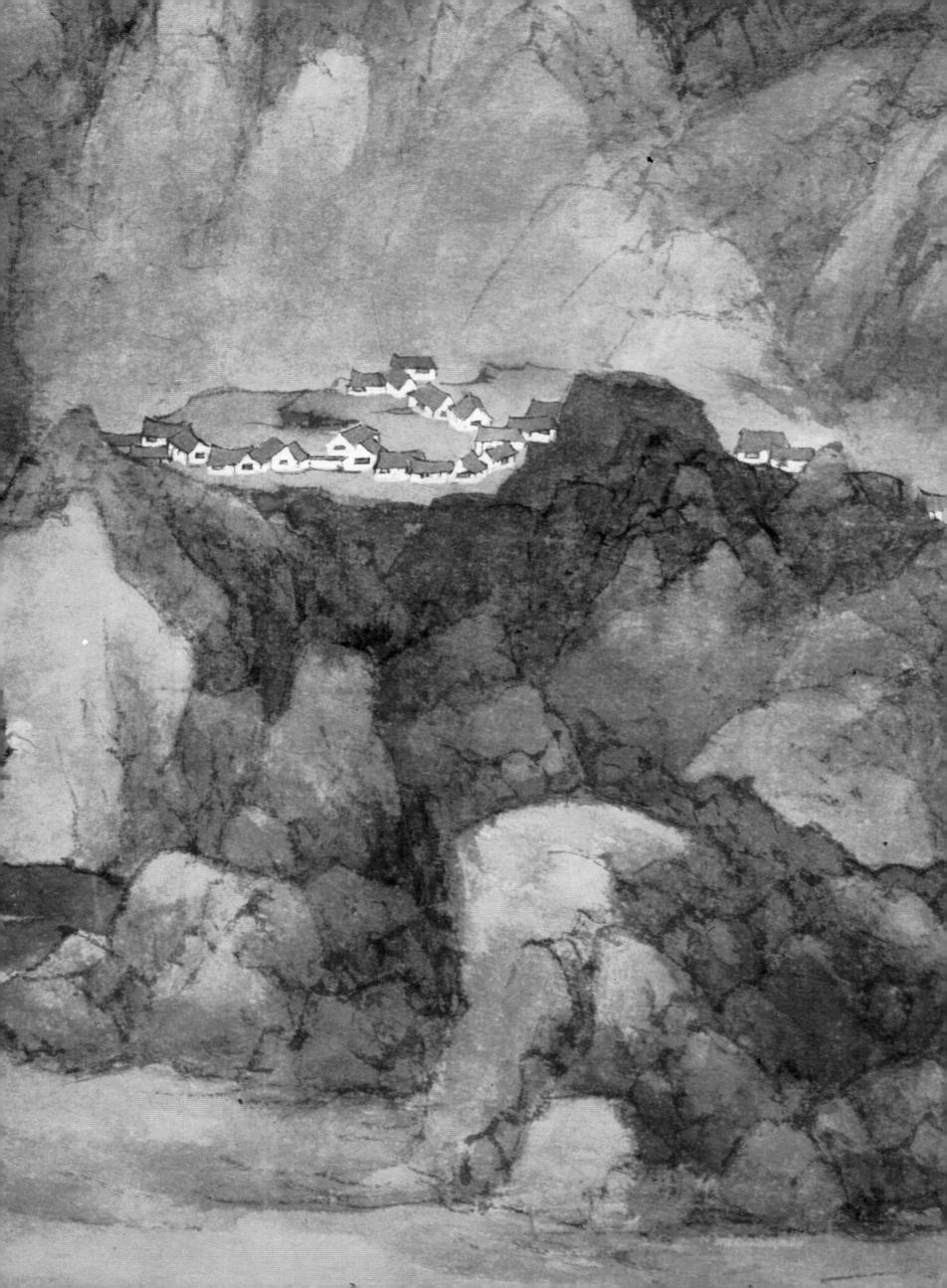

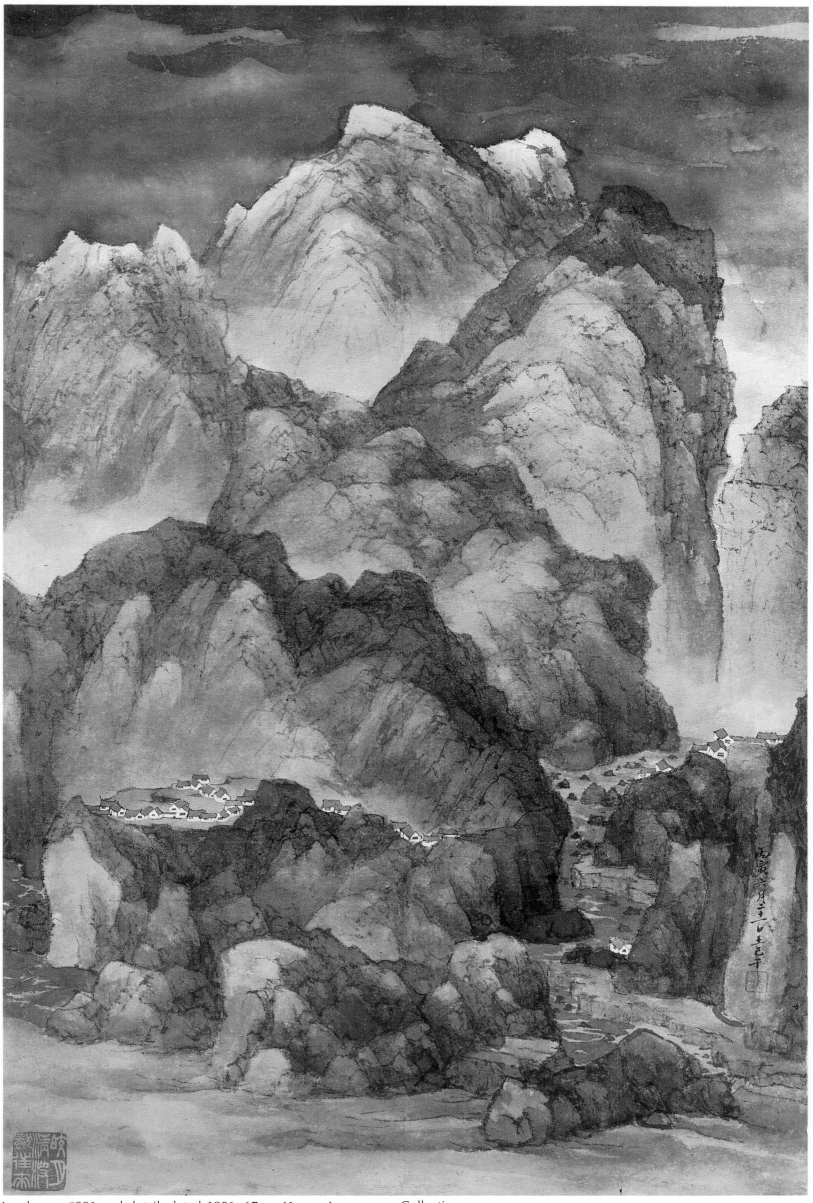

Landscape #901 and detail, dated 1986, 67 × 41 cm, Anonymous Collection

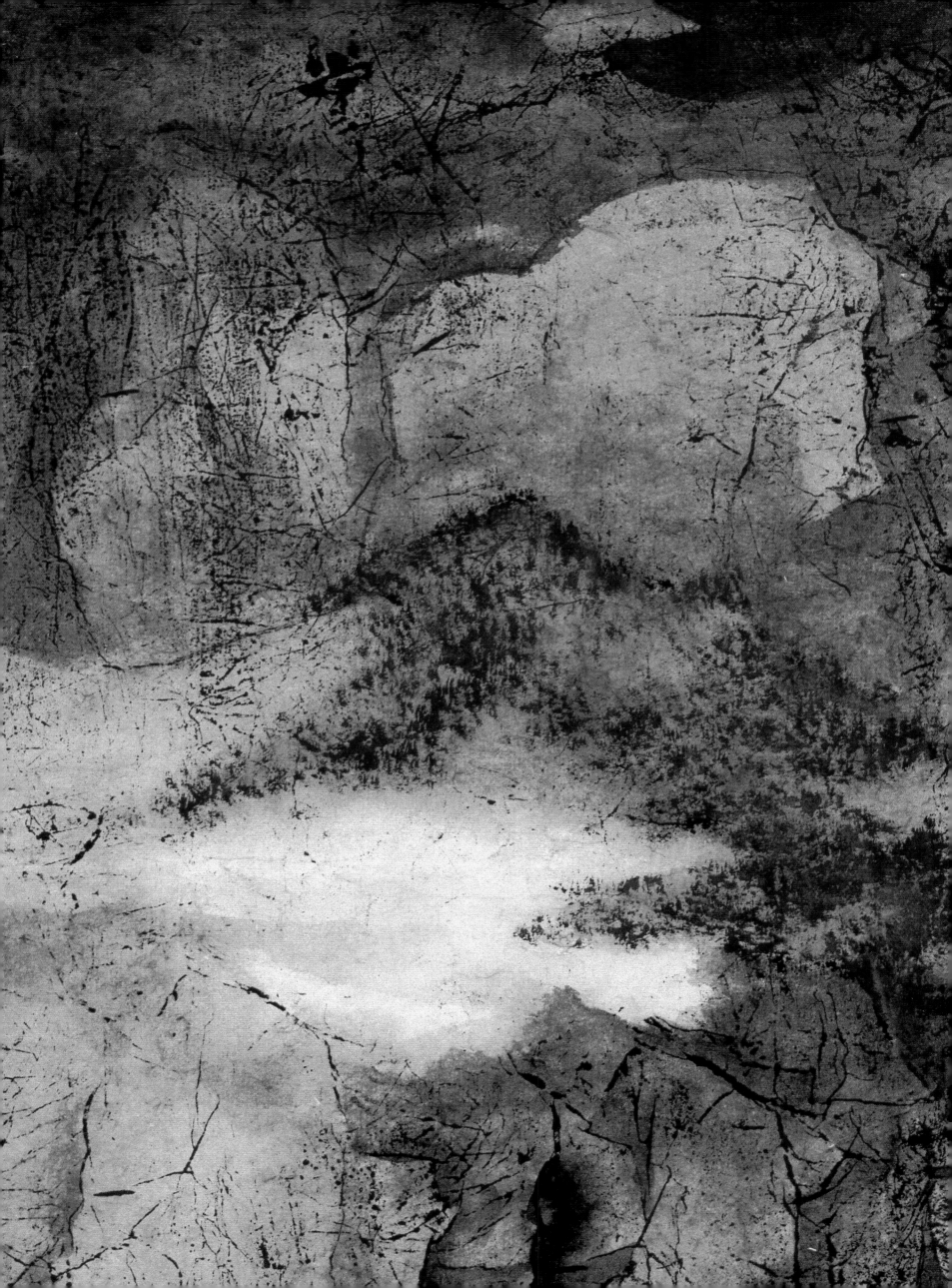

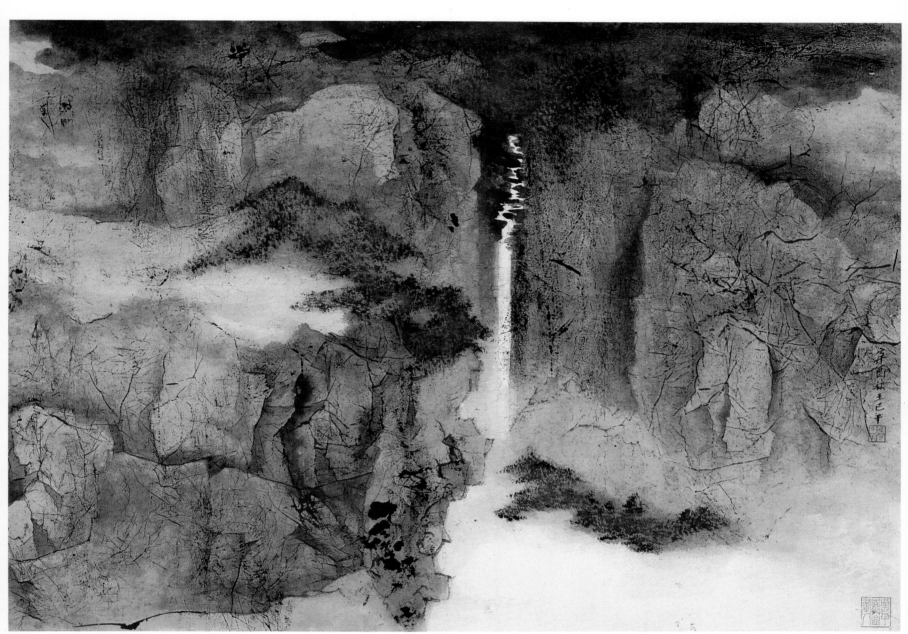

Landscape #394 and detail, dated 1981, 60.7 × 86 cm, Ann and Michael Loeb Collection

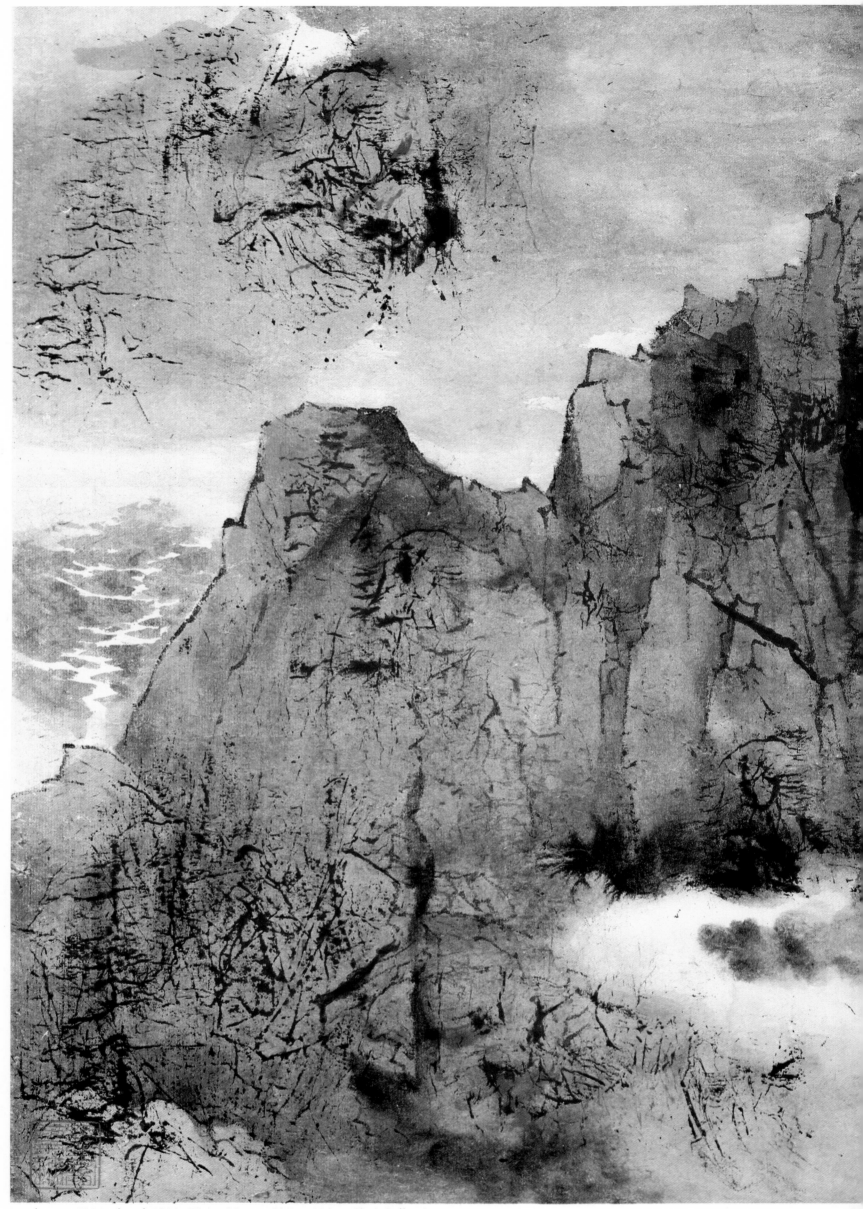

Landscape #391, dated 1981, 59 × 84 cm, Ch'ing Hsien Chai Collection

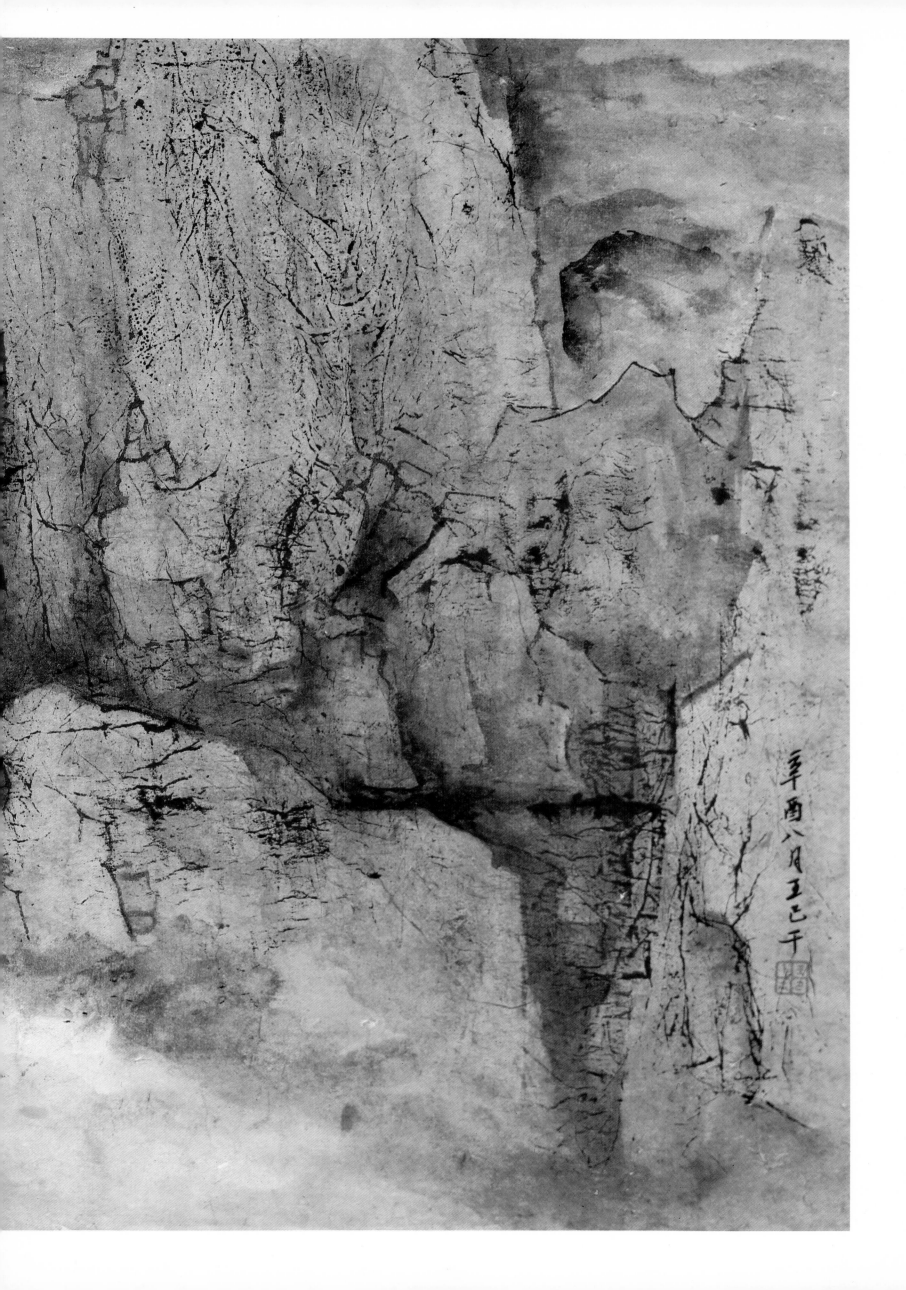

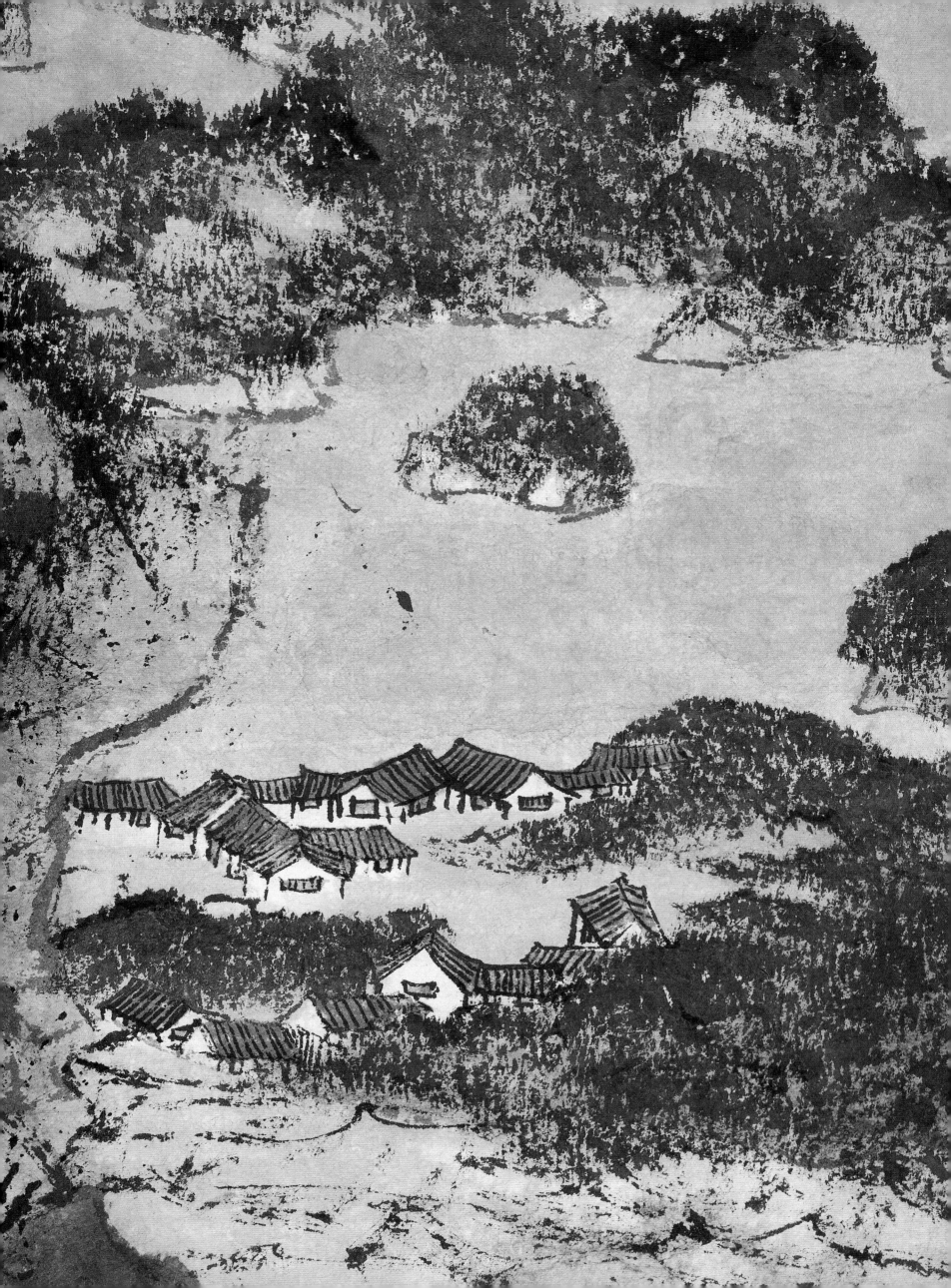

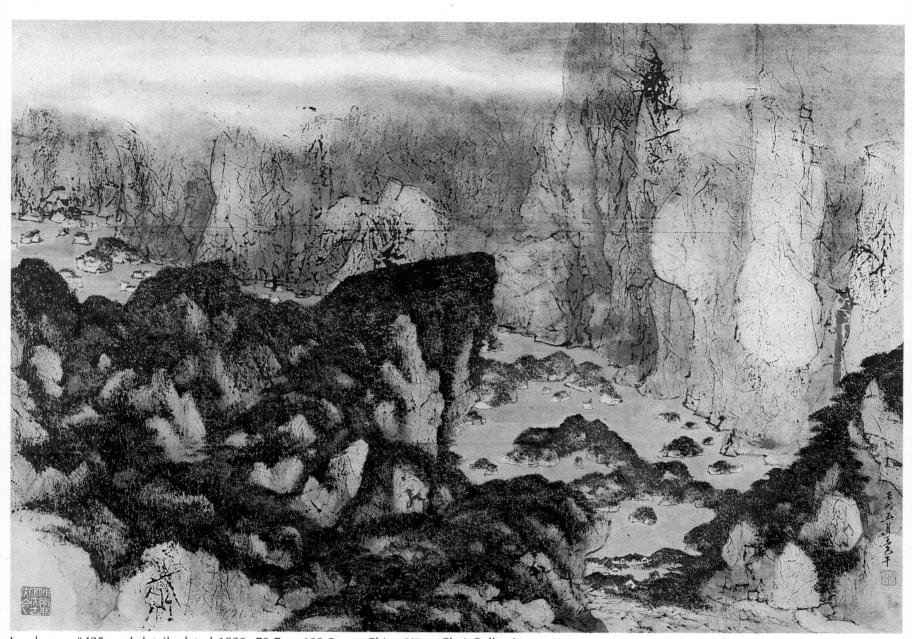

Landscape #425 and detail, dated 1982, 72.7 × 103.5 cm, Ching Yüan Chai Collection

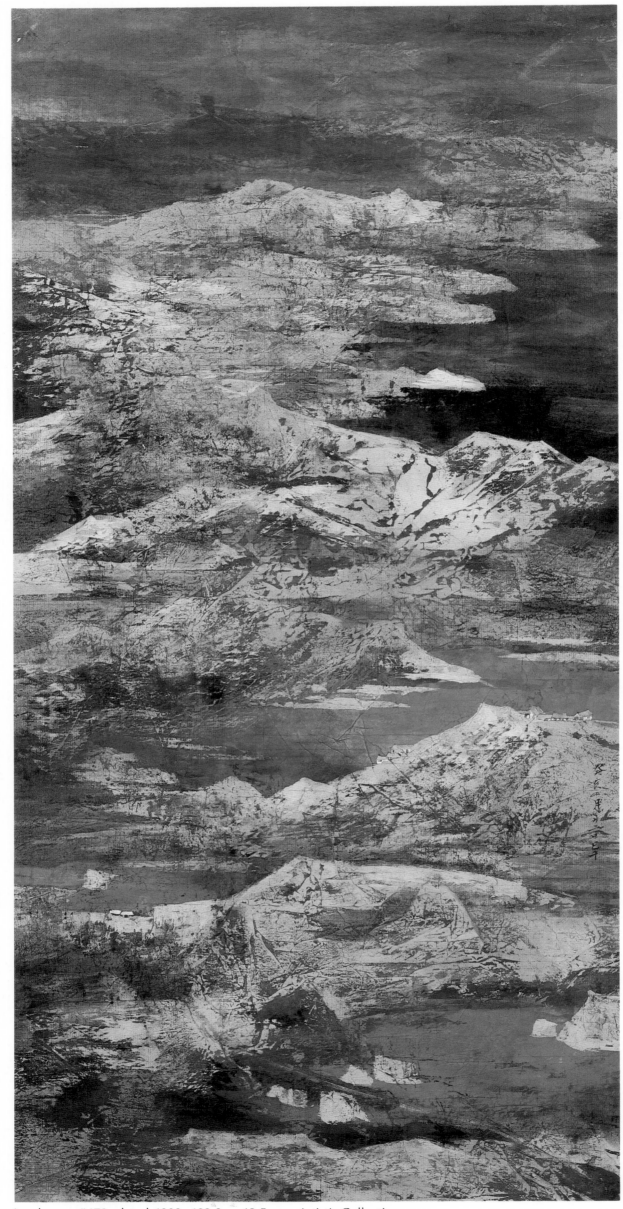

Landscape #472, dated 1983, 103.3 × 49.5 cm, Artist's Collection

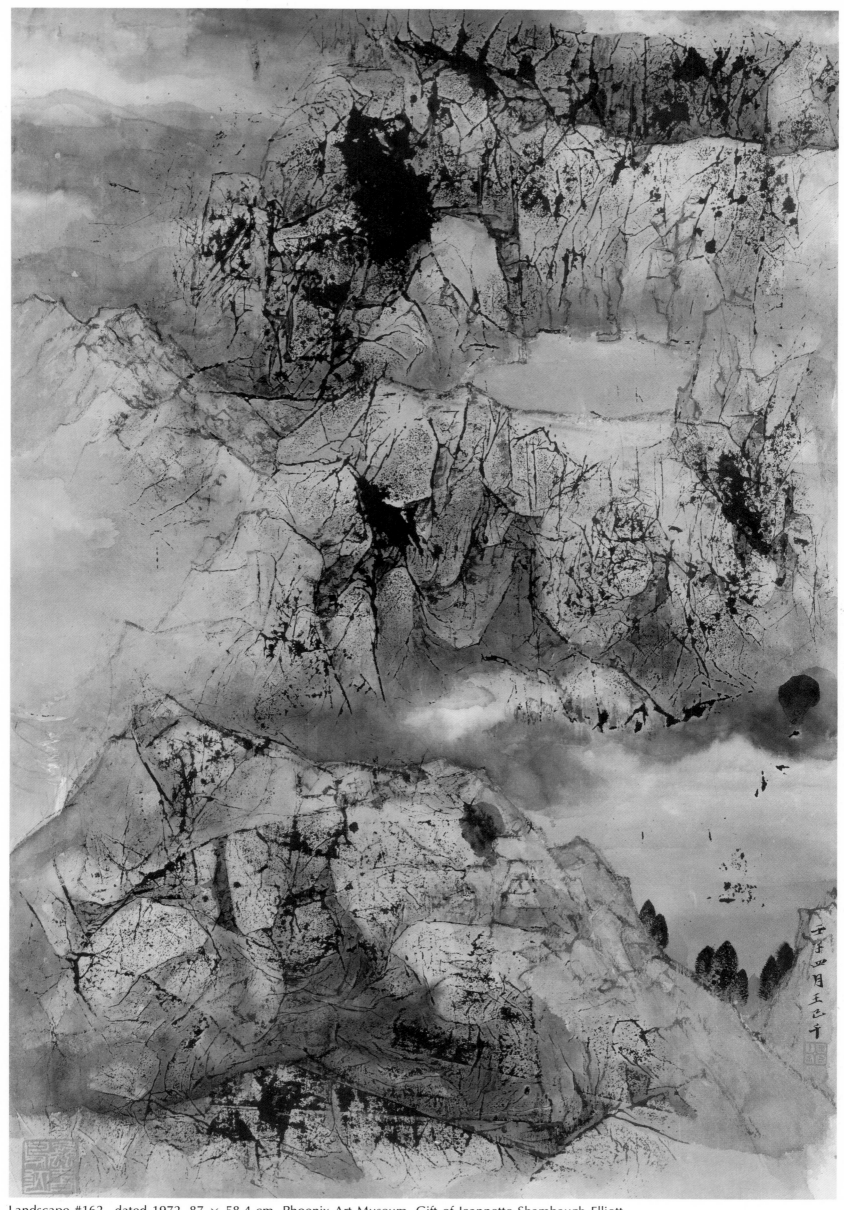

Landscape #162, dated 1972, 87 × 58.4 cm, Phoenix Art Museum, Gift of Jeannette Shambaugh Elliott

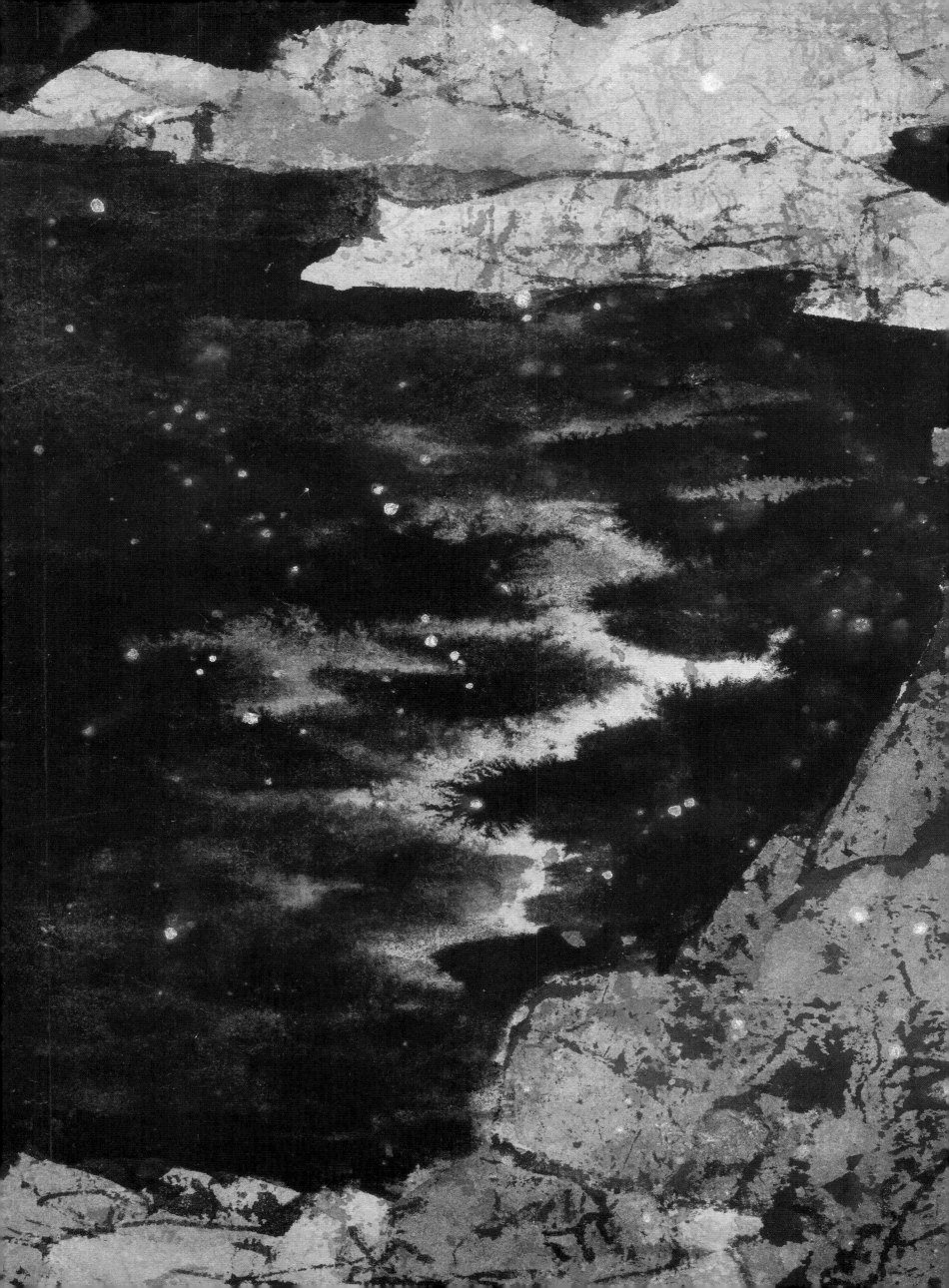

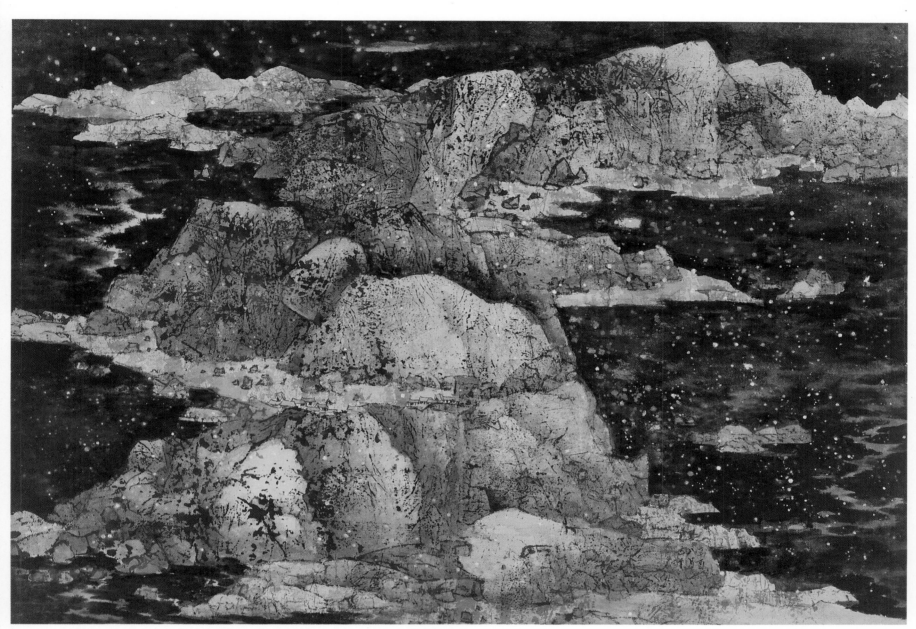

Landscape #397 and detail, dated 1981, 61 × 86.3 cm, Anonymous Collection

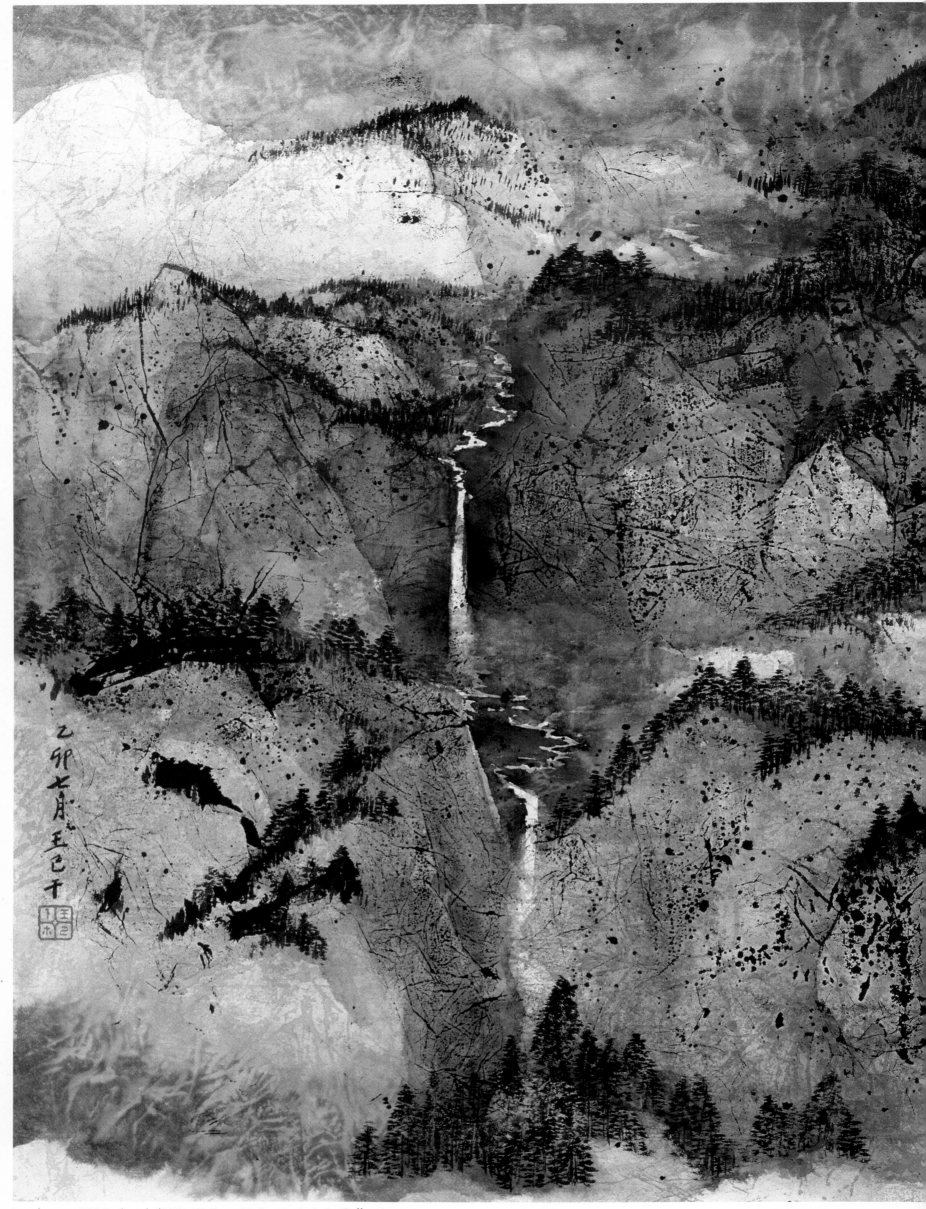

Landscape #334, dated 1975, 59.5 × 89.8 cm, Artist's Collection

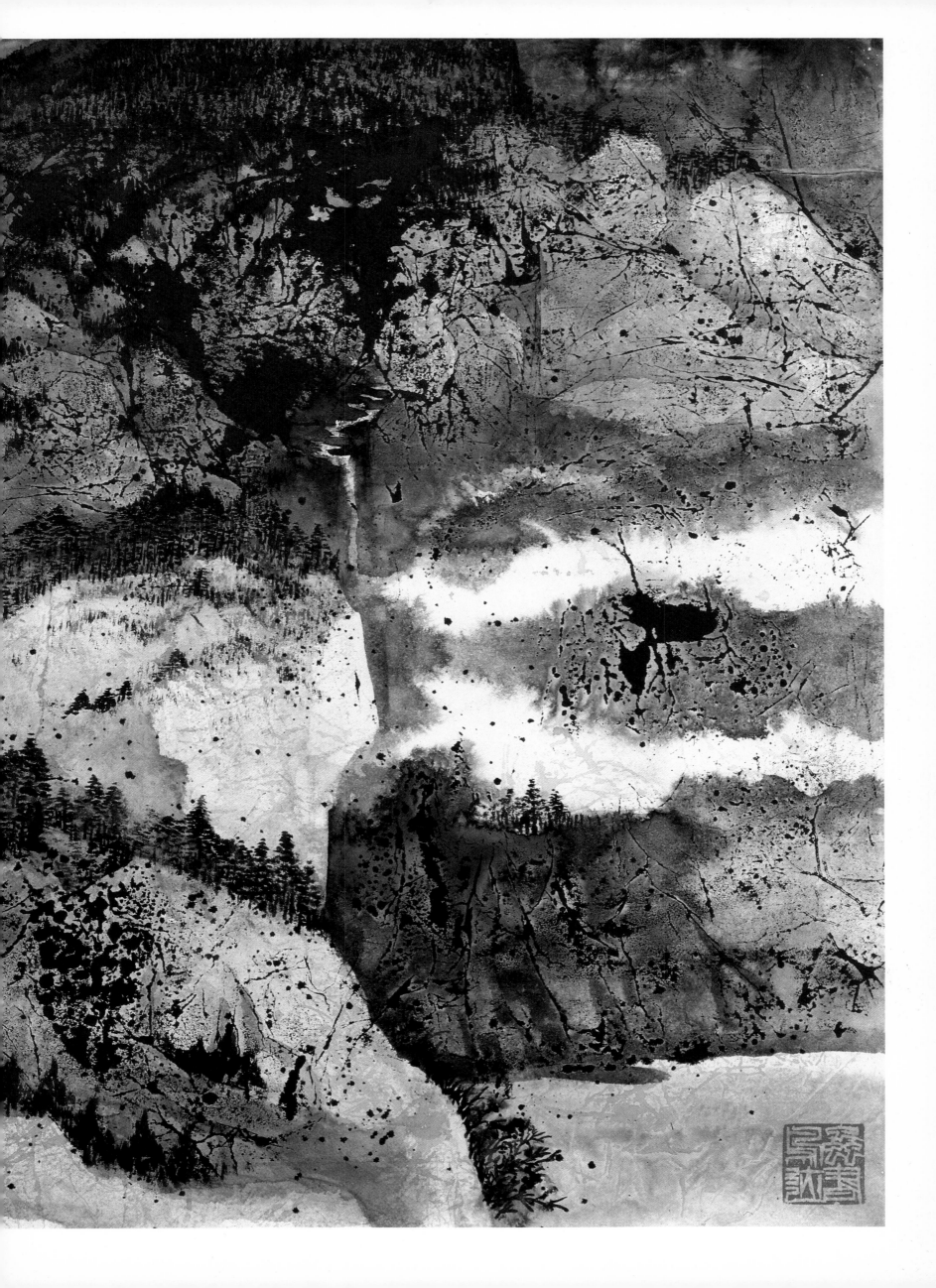

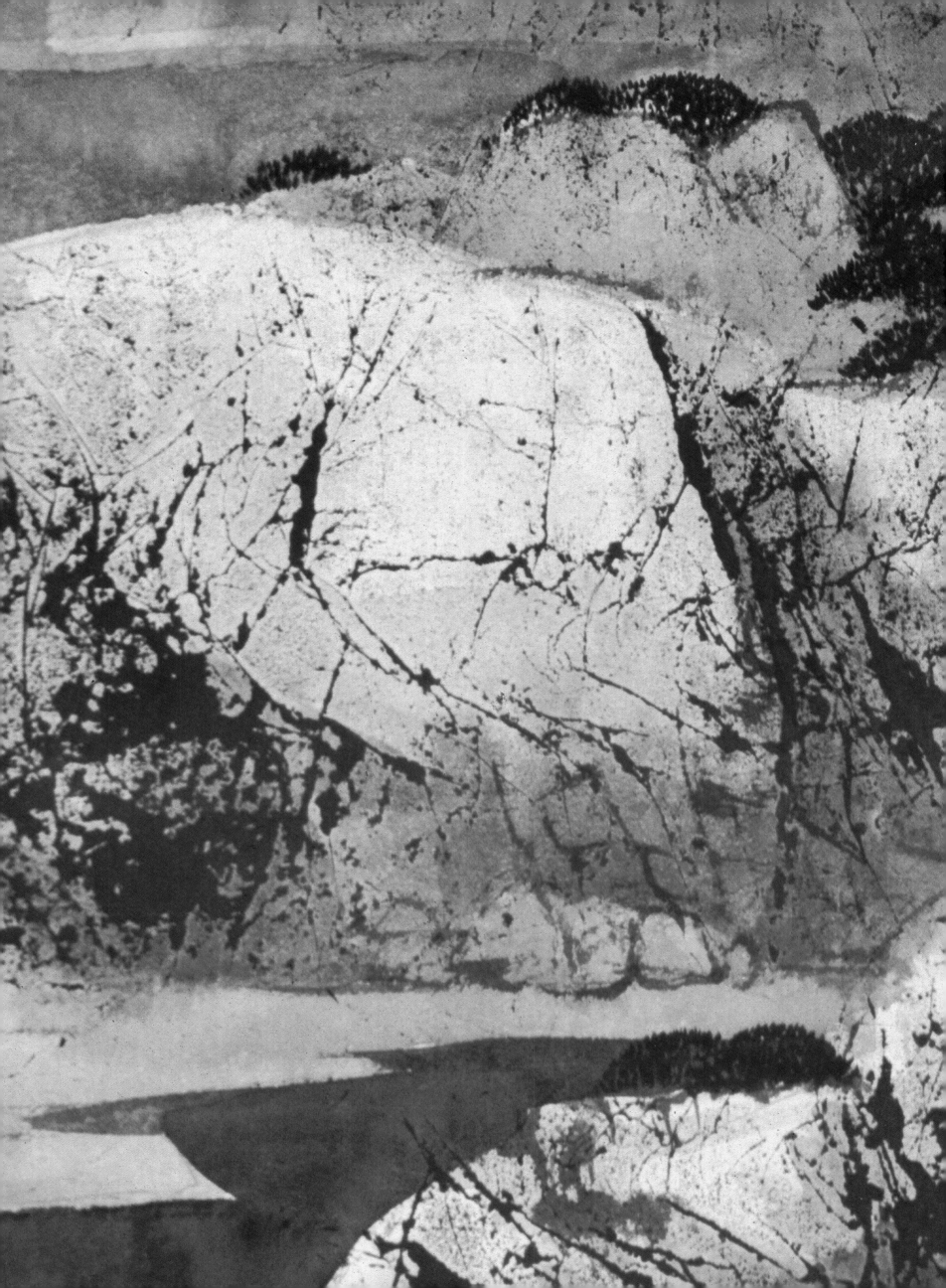

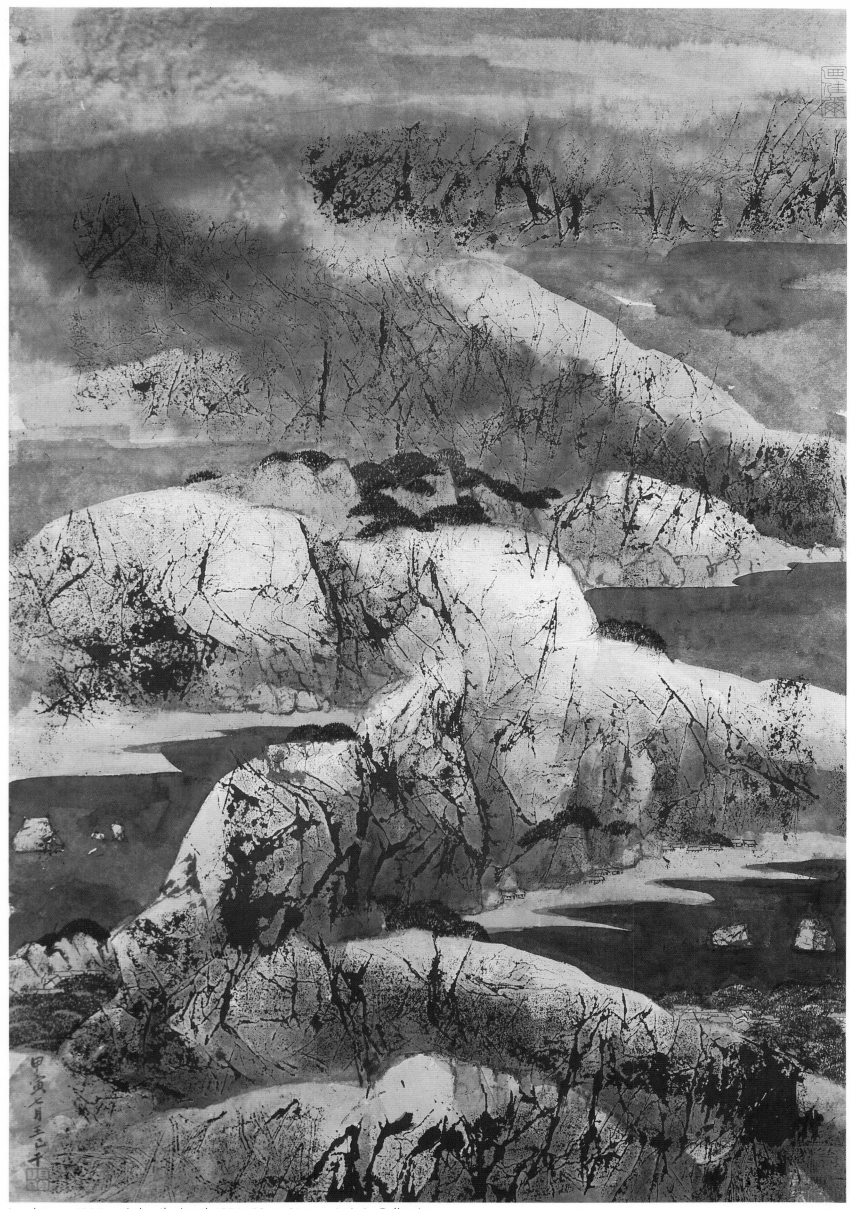

Landscape #305 and detail, dated 1974, 90 × 61 cm, Artist's Collection

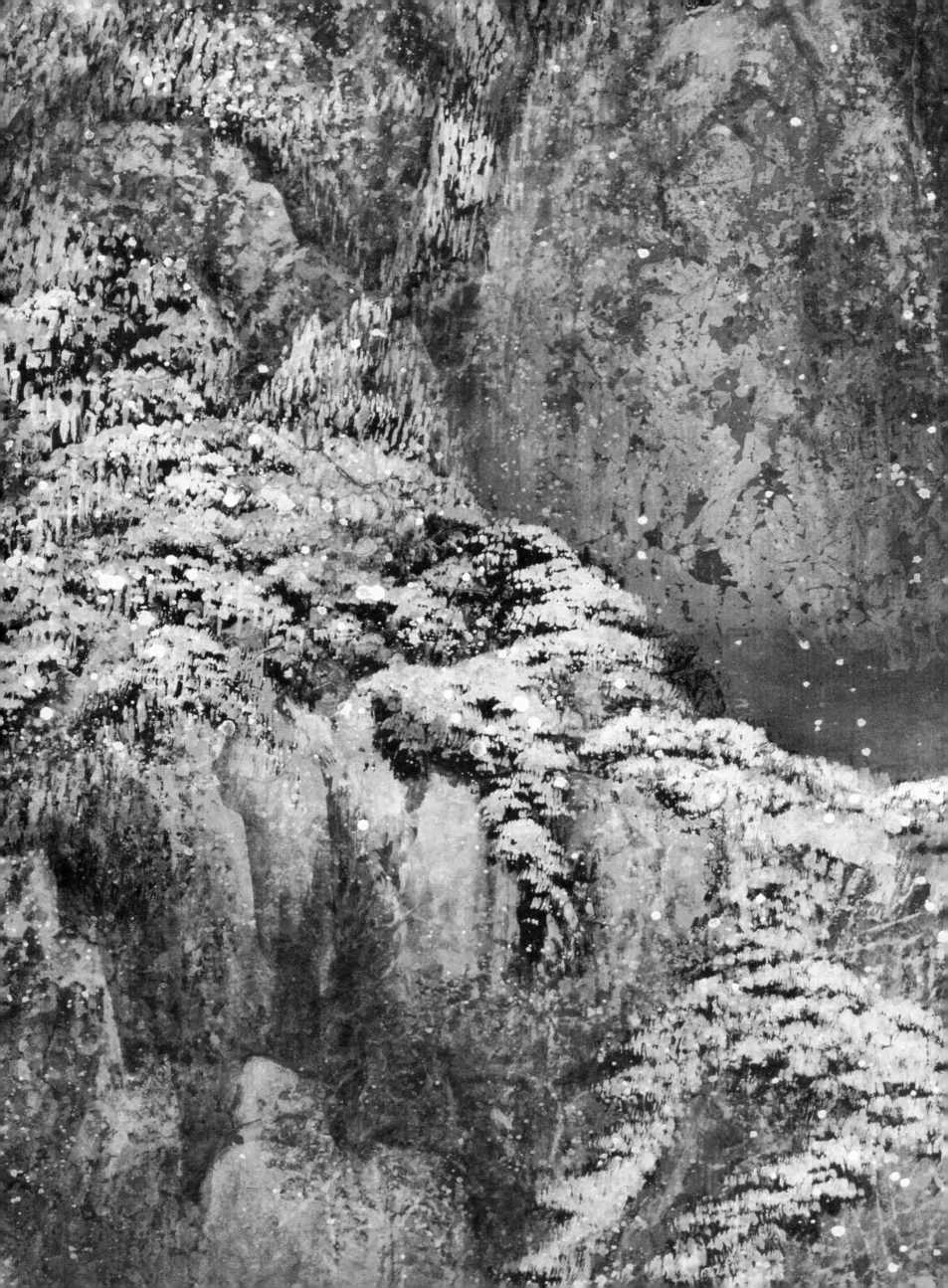

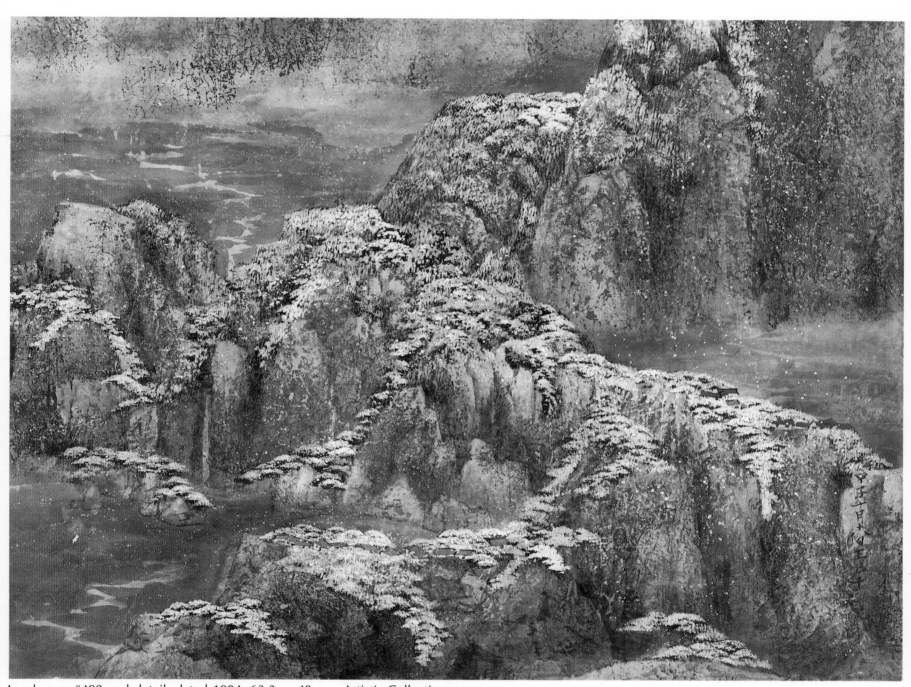

Landscape #498 and detail, dated 1984, 63.3 × 48 cm, Artist's Collection

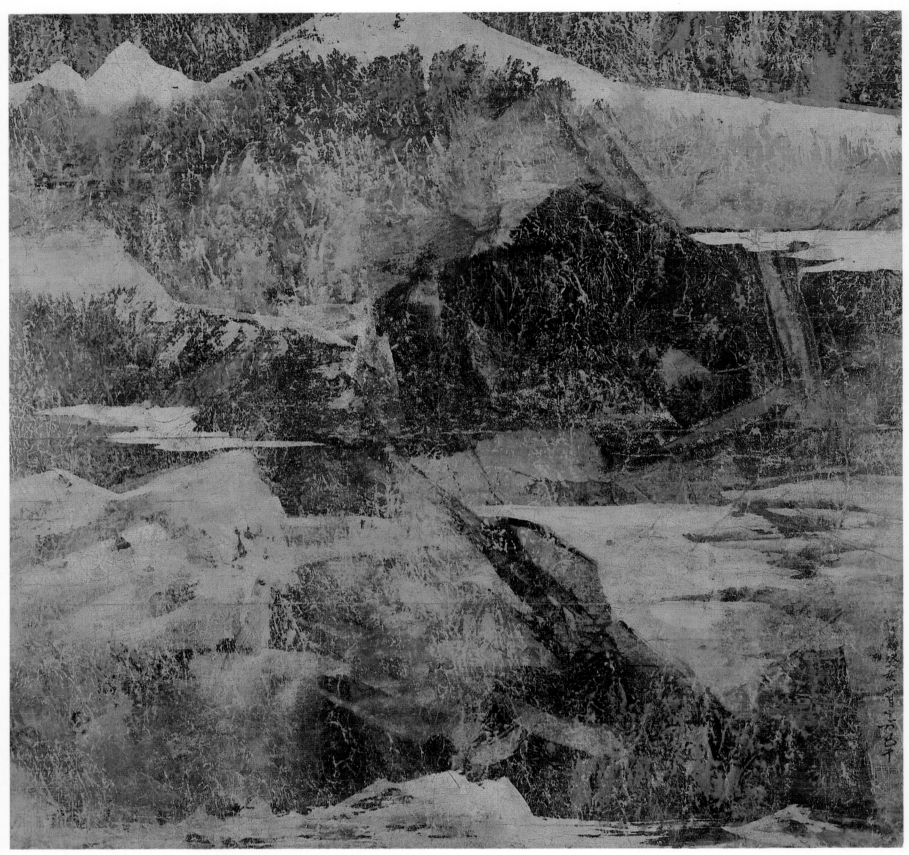

Landscape #469, dated 1983, 50.2 × 51.4 cm, Artist's Collection

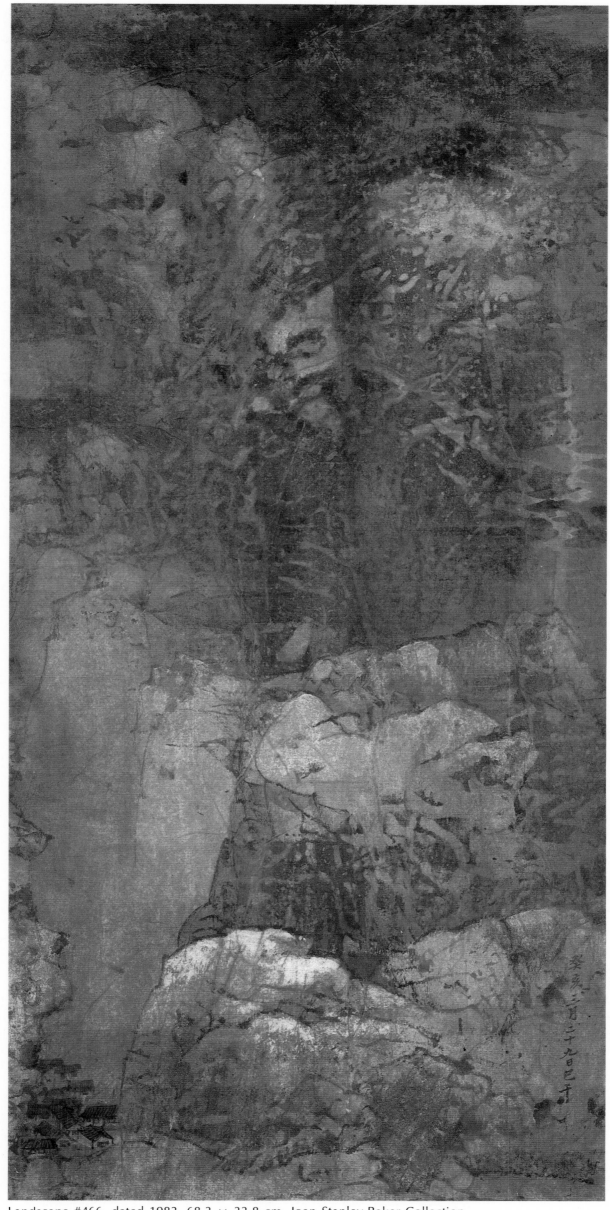

Landscape #466, dated 1983, 68.3 × 33.8 cm, Joan Stanley-Baker Collection

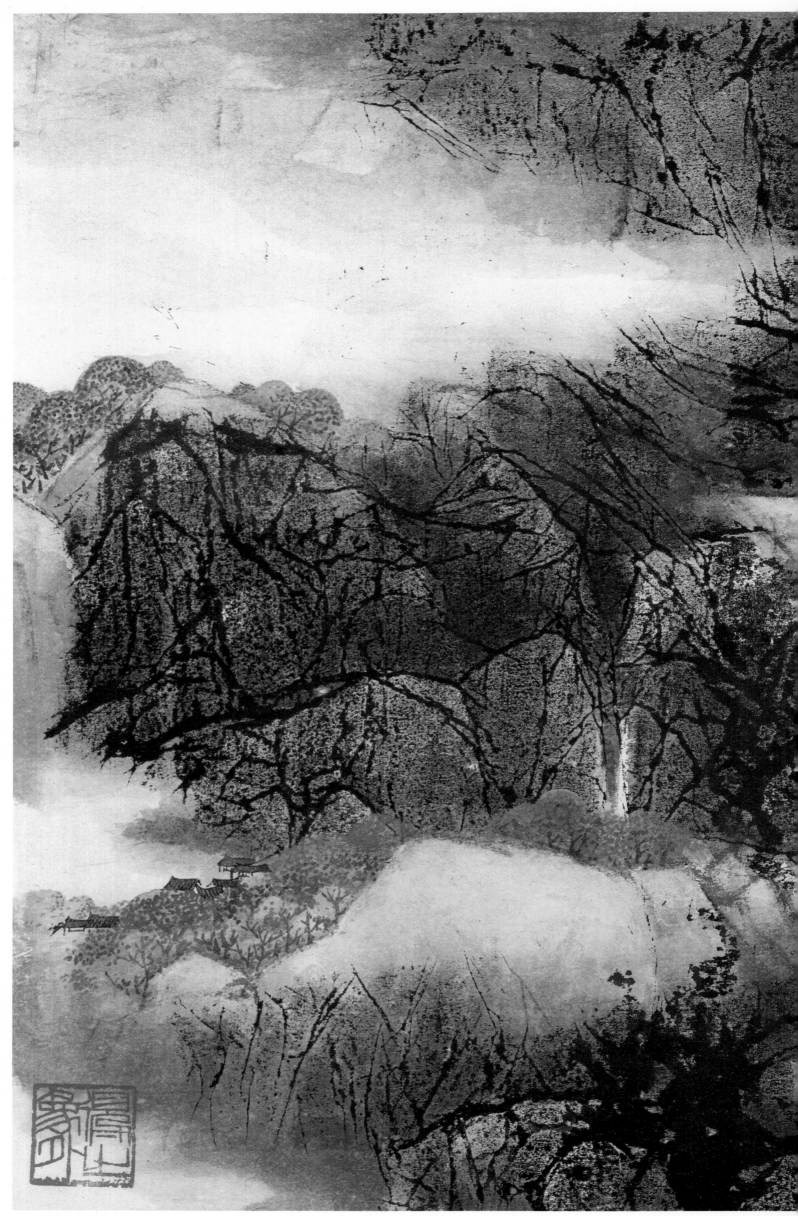

Landscape #93, dated 1969, 47.5 × 62 cm, Artist's Collection

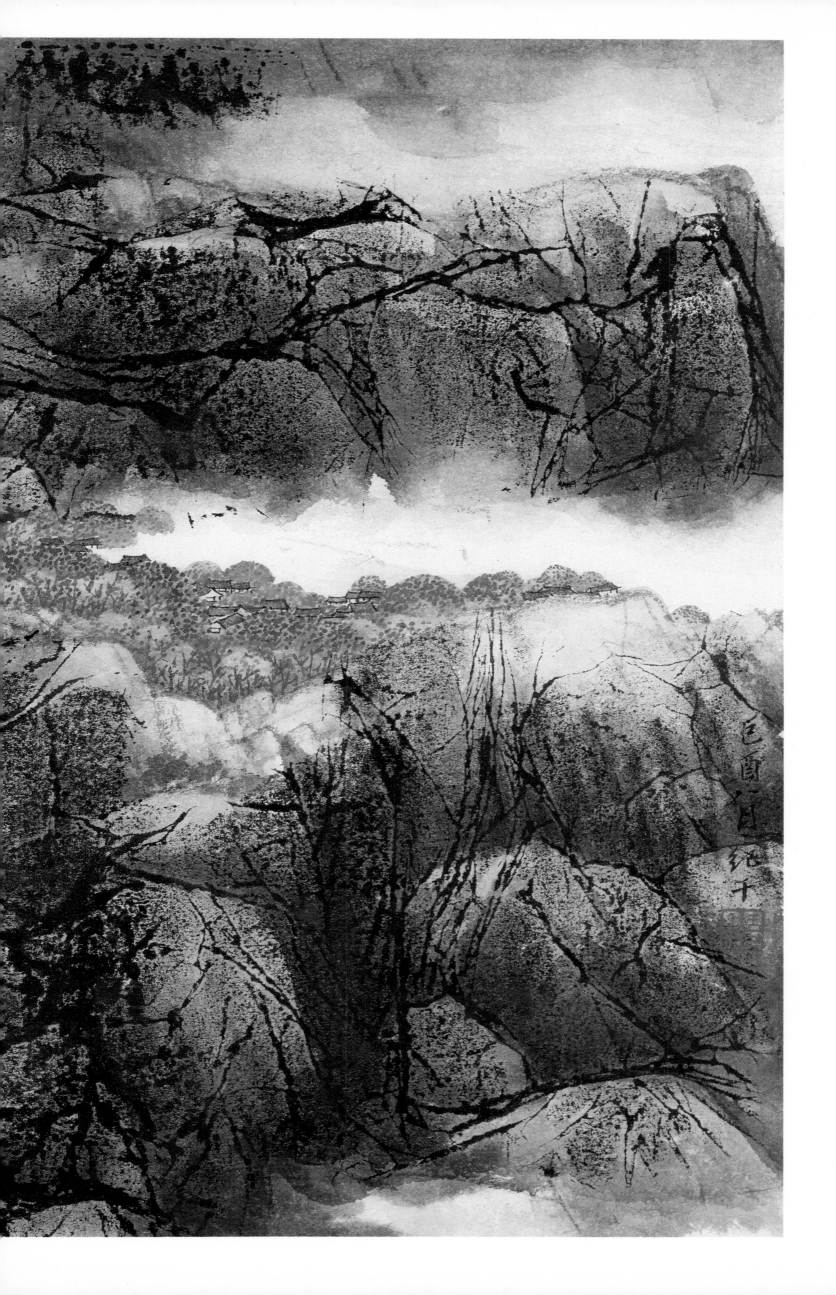

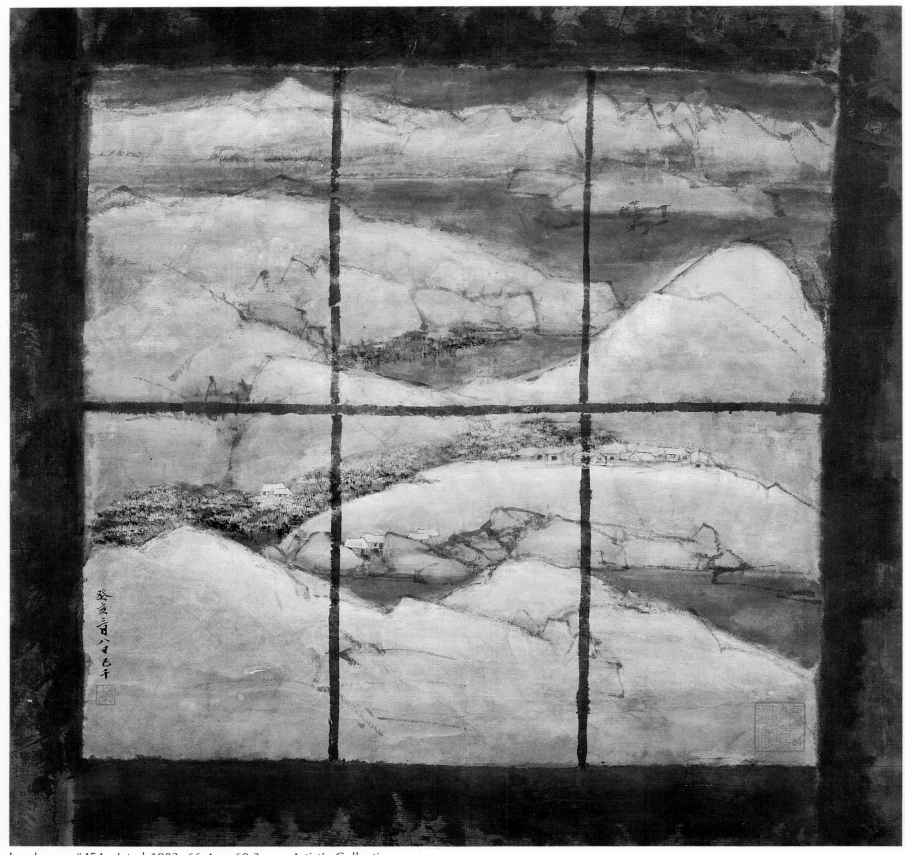

Landscape #454, dated 1983, 66.4 × 68.3 cm, Artist's Collection

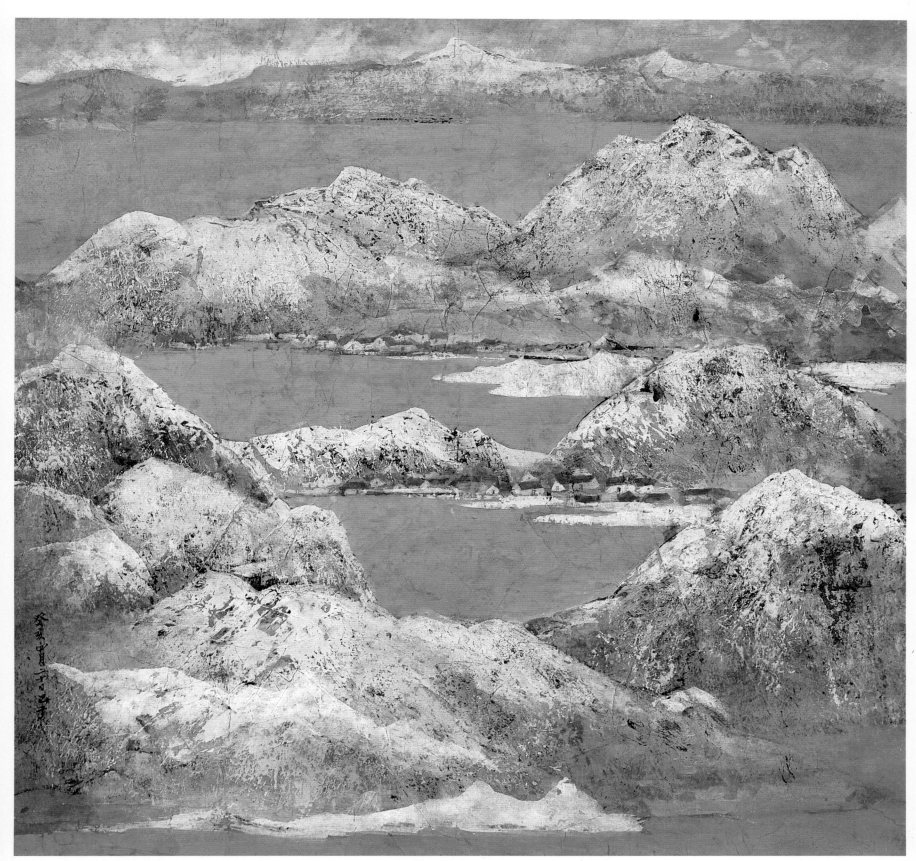

Landscape #471, dated 1983, 65.8 × 67.7 cm, Shuisongshi Shanfang Collection

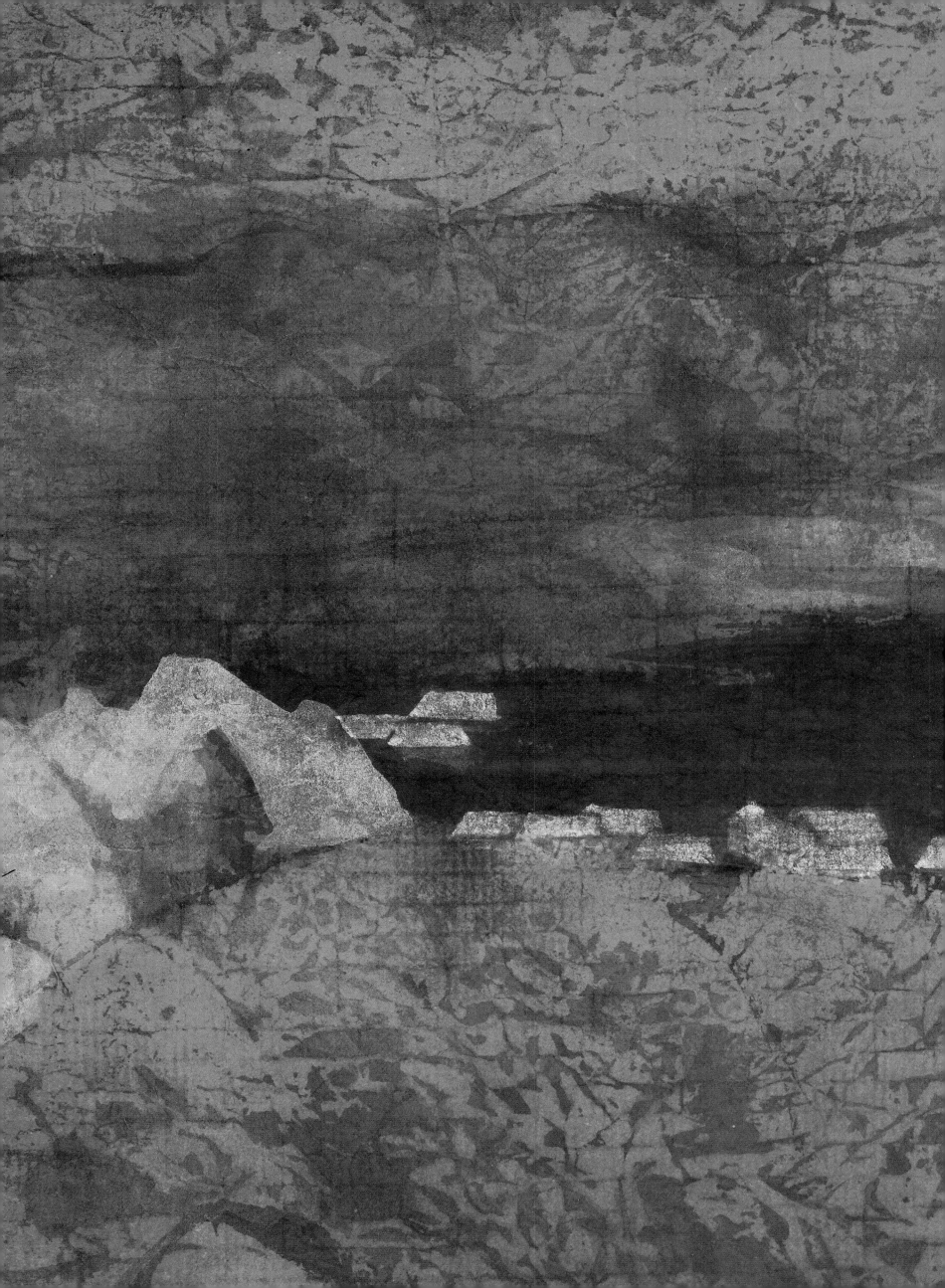

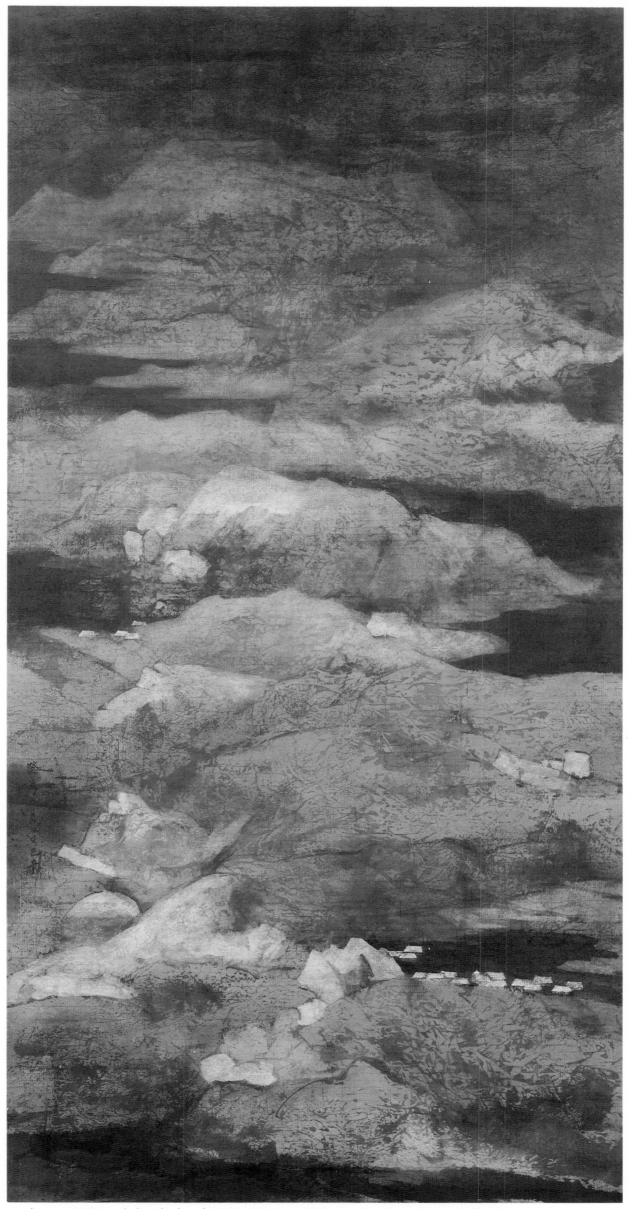

Landscape #475 and detail, dated 1983, 101.2 × 50.6 cm, Yien-koo Wang Collection

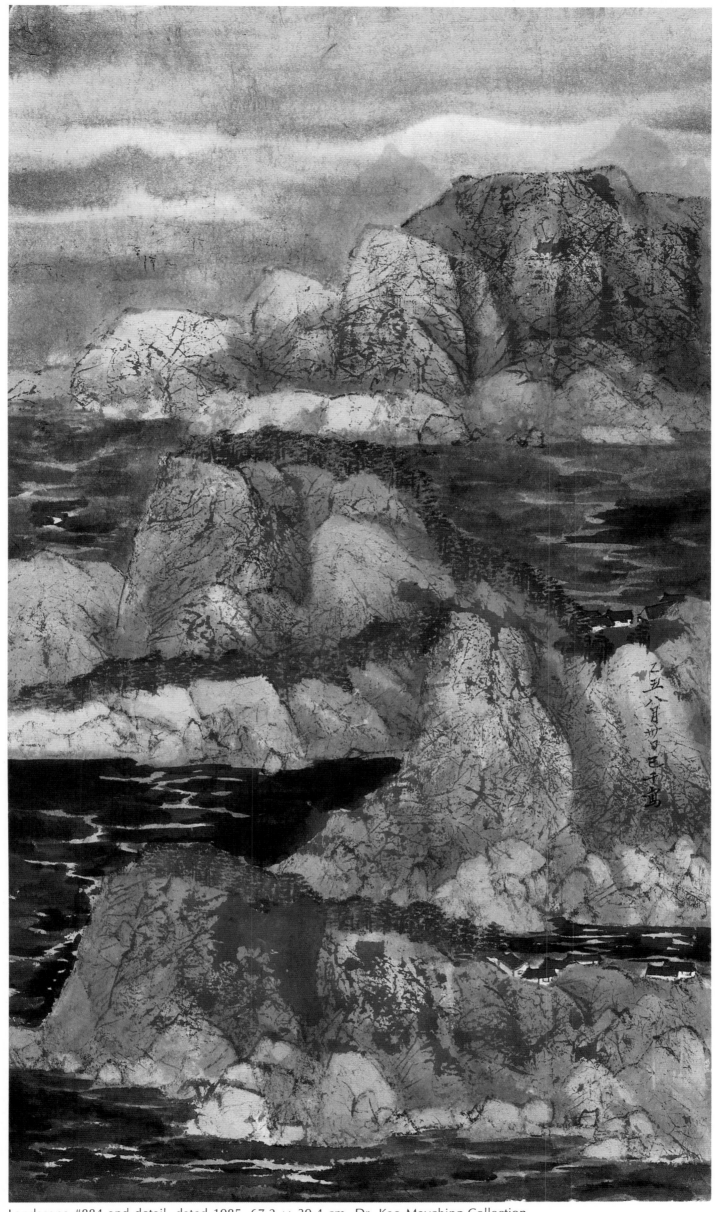

Landscape #884 and detail, dated 1985, 67.2 × 39.4 cm, Dr. Kao Mayching Collection

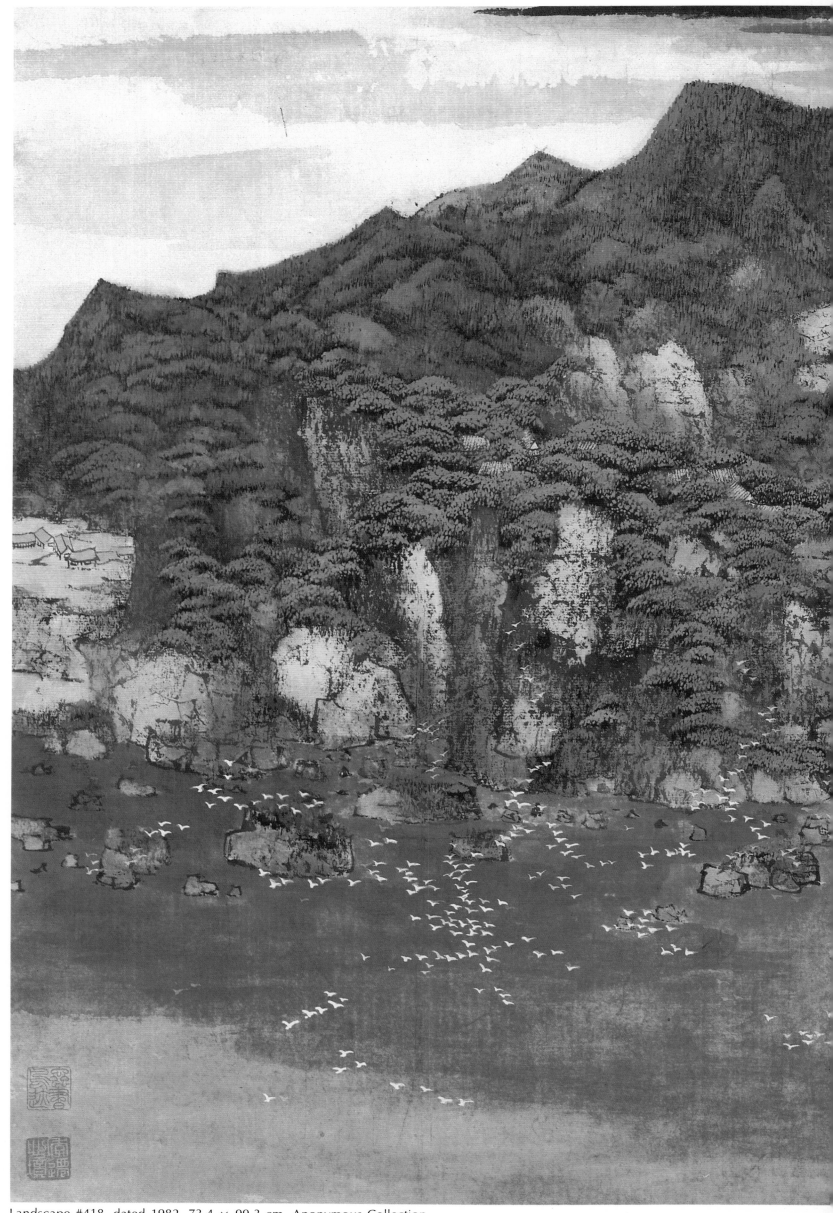

Landscape #418, dated 1982, 73.4 × 99.3 cm, Anonymous Collection

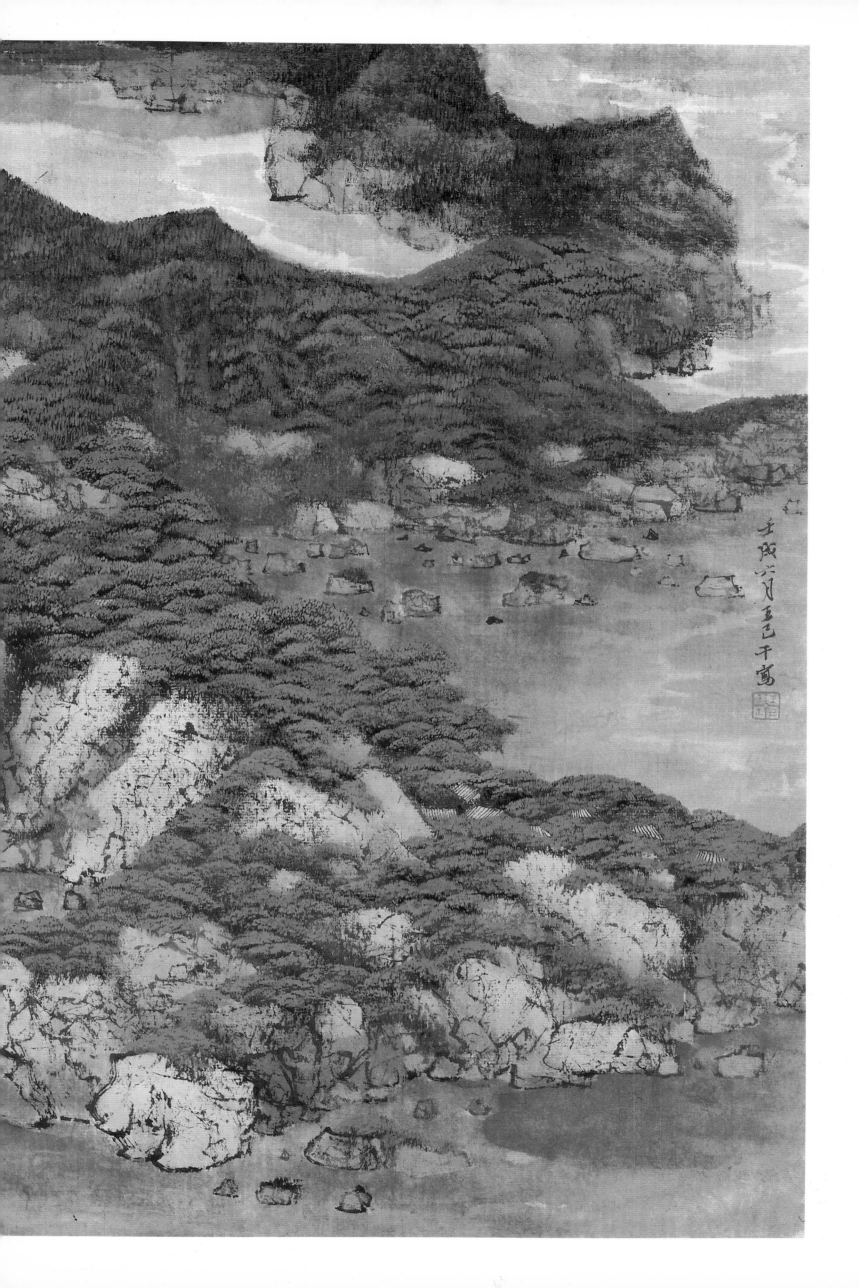

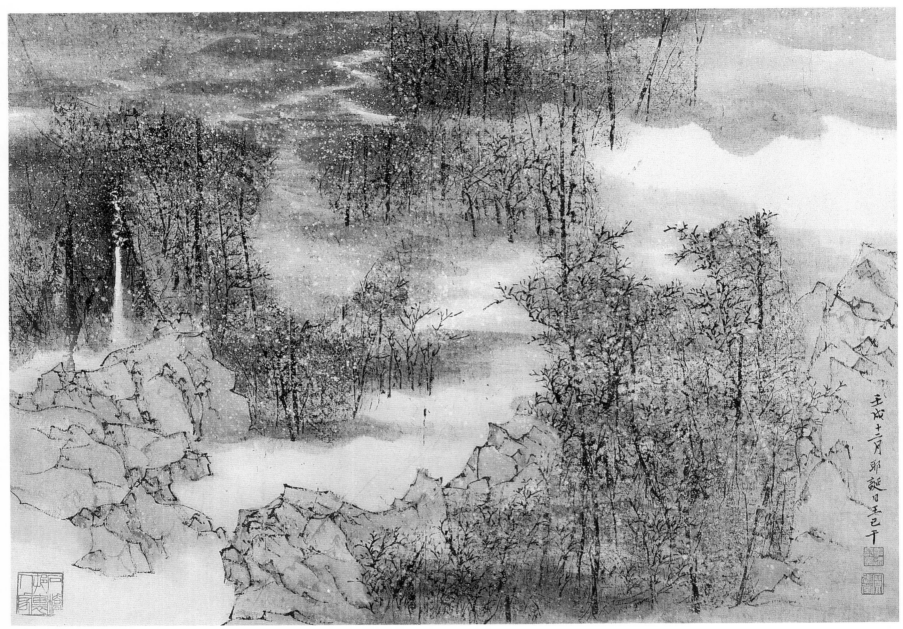

Landscape #447, dated 1982, 58.2 × 81.6 cm, Mrs. Tseng-hsi Chan Collection

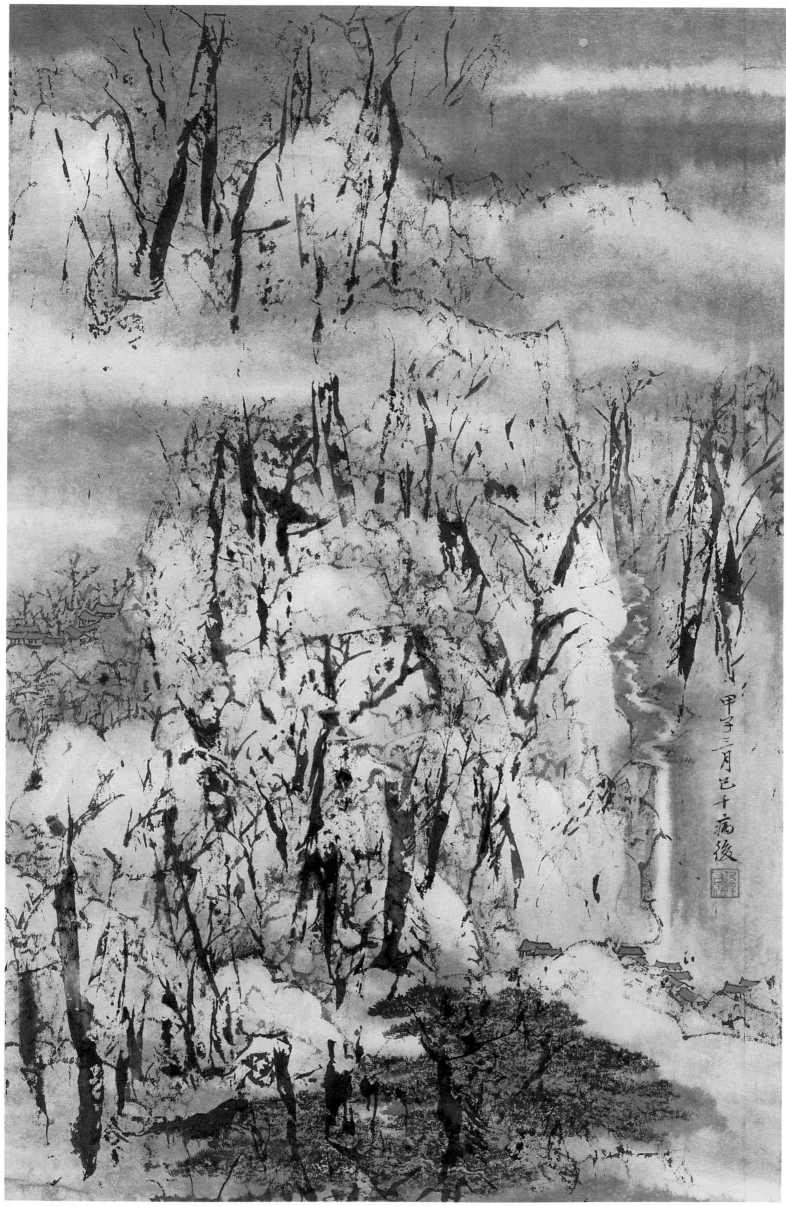

Landscape #488, dated 1984, 67 × 41.1 cm, Mr. and Mrs. Wai-kam Ho Collection

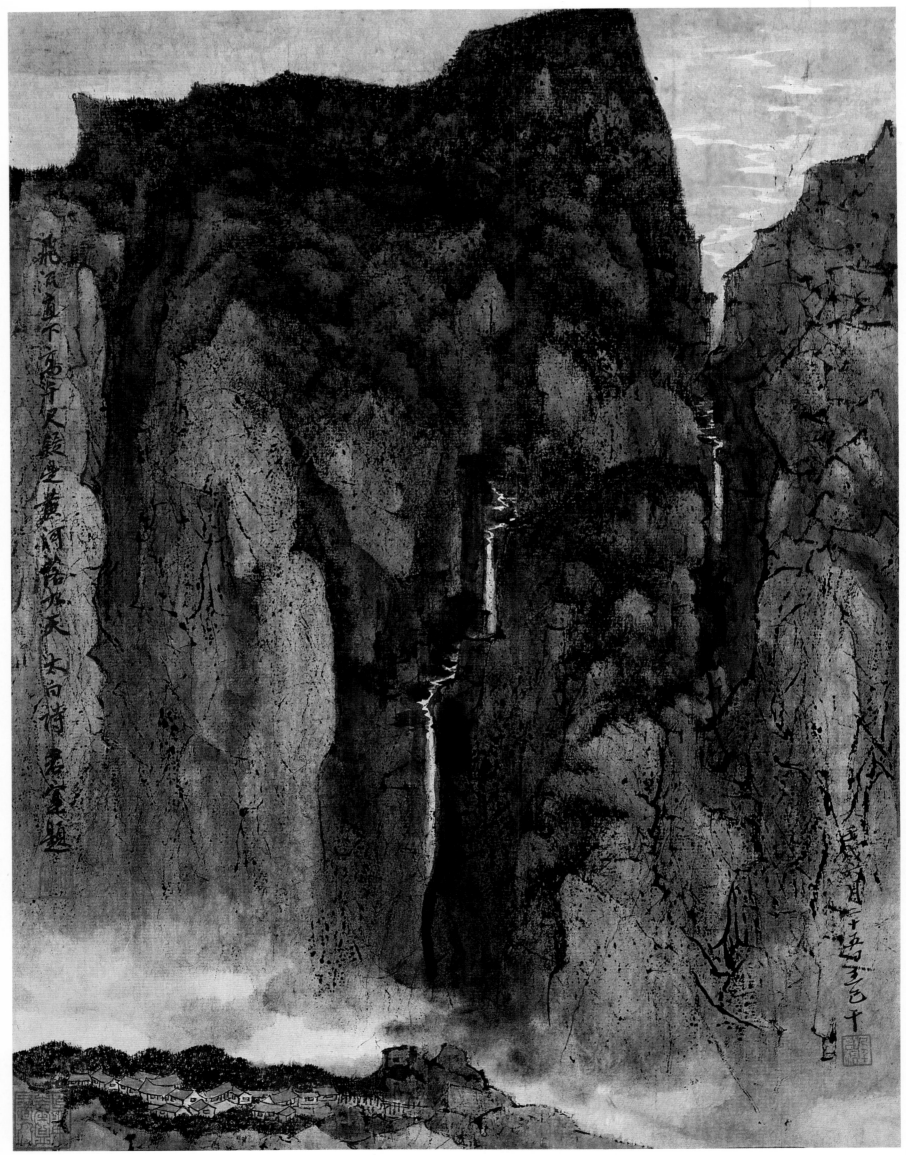

Landscape #P3, dated 1982, 62 × 46 cm, Dr. and Mrs. Sesin Jong Collection

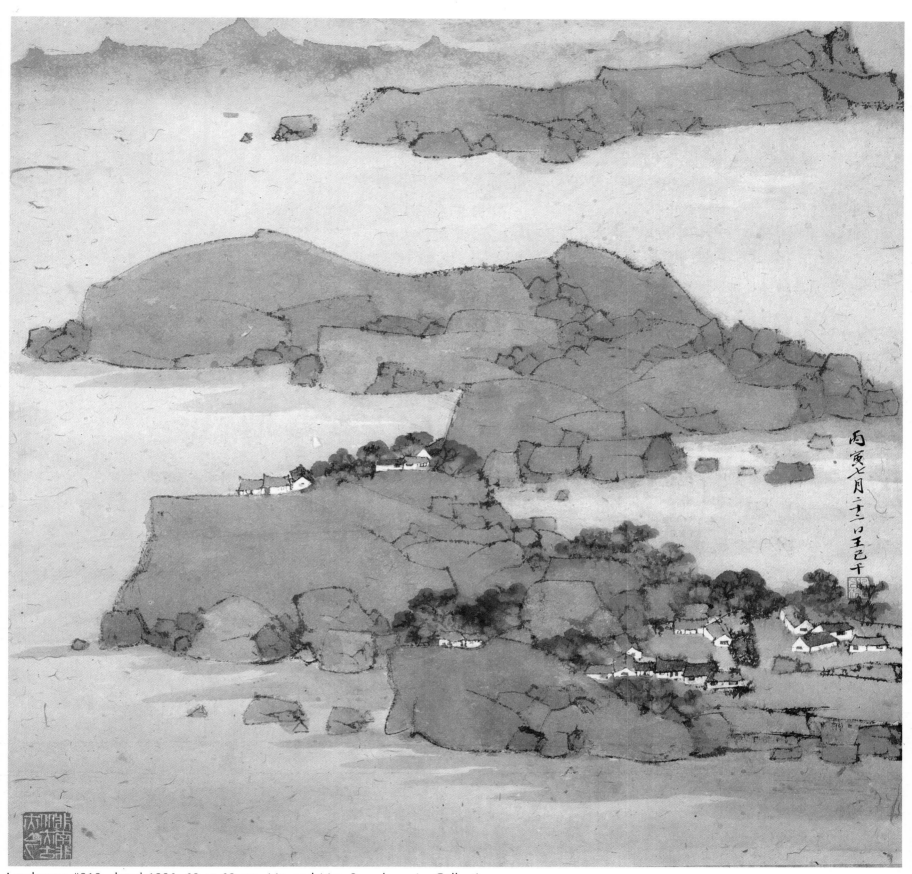

Landscape #910, dated 1986, 62 × 62 cm, Mr. and Mrs. Sun-chang Lo Collection

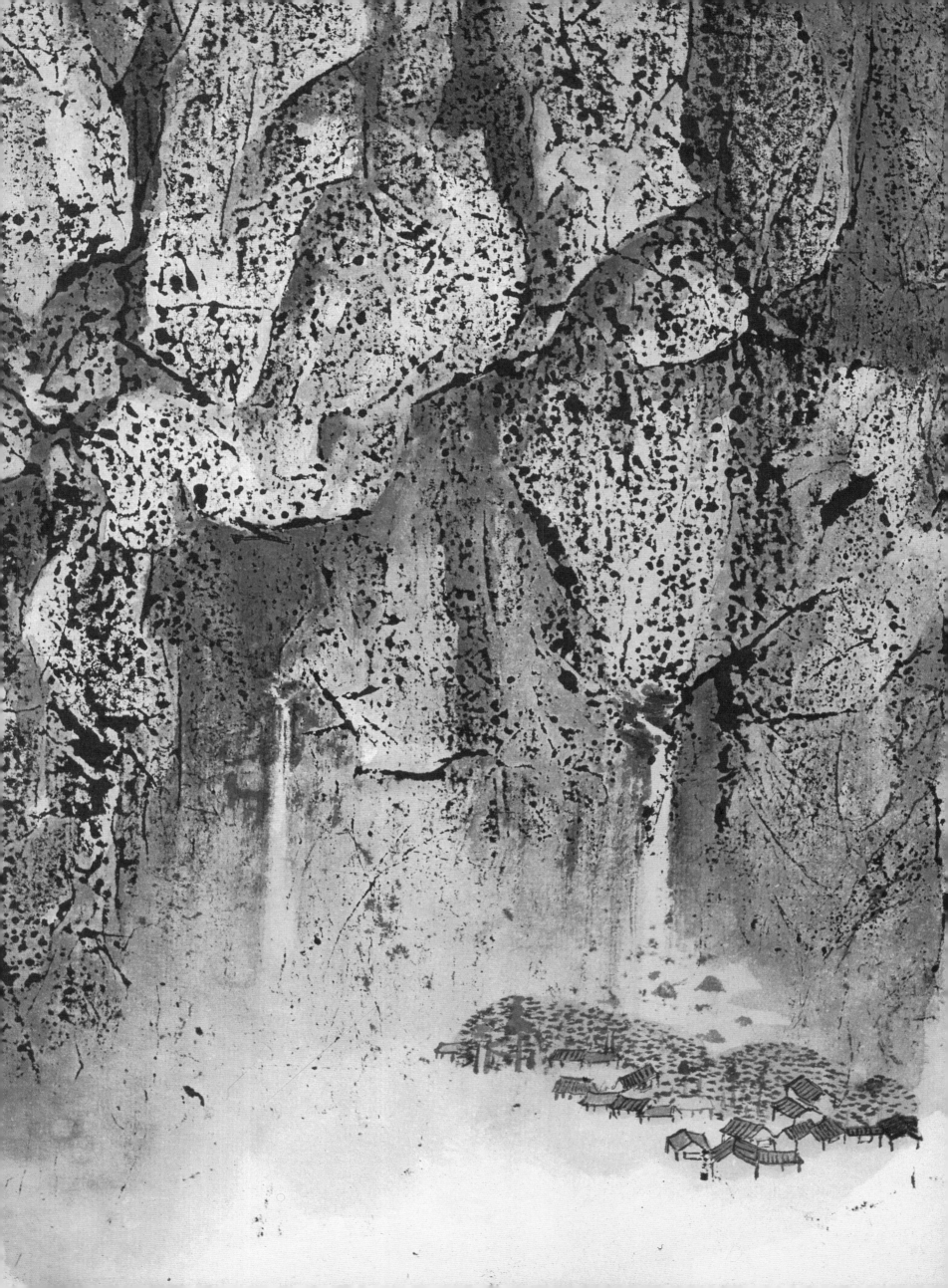

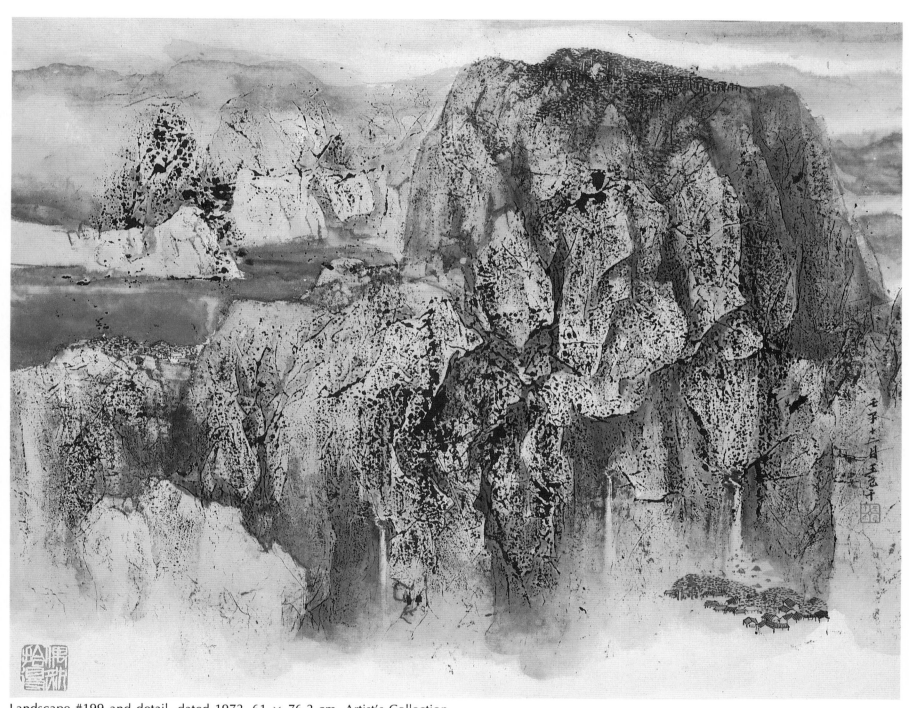

Landscape #199 and detail, dated 1972, 61 × 76.2 cm, Artist's Collection

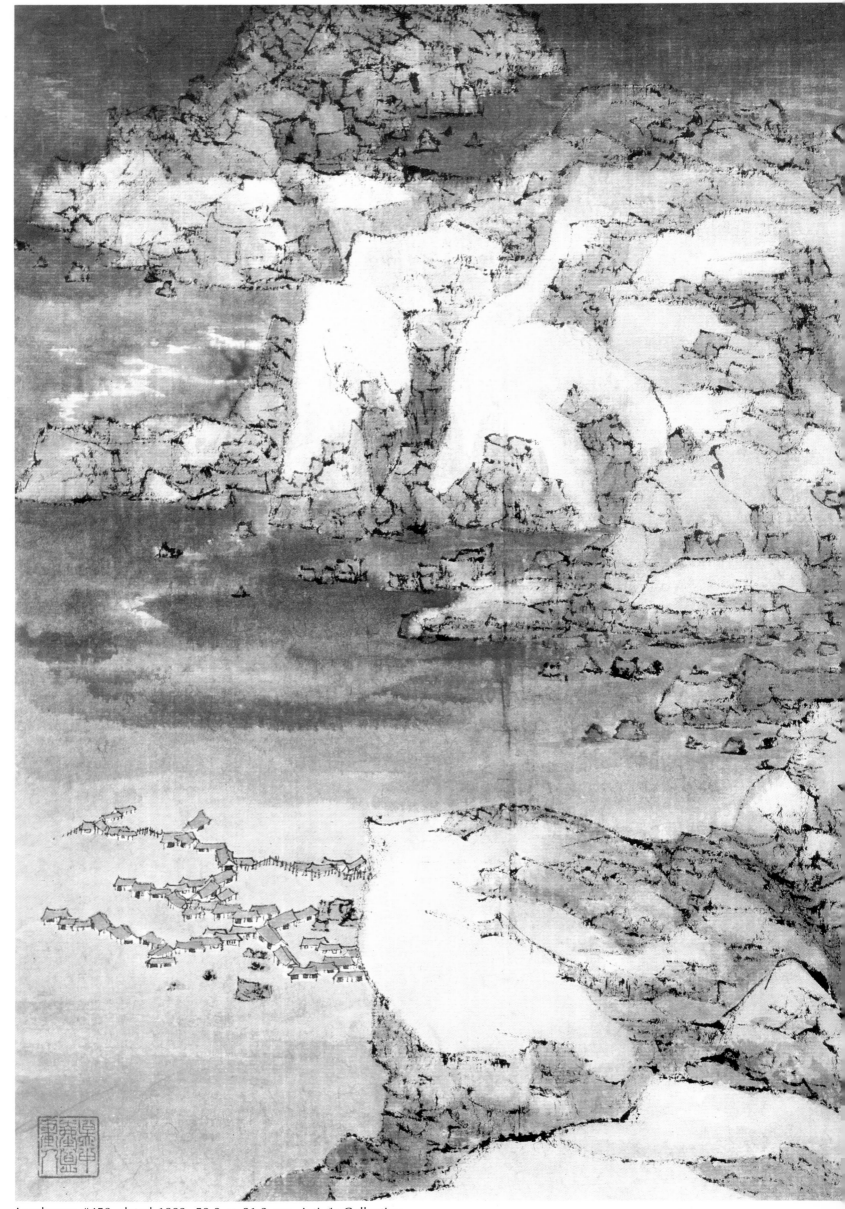

Landscape #450, dated 1983, 58.8 × 81.3 cm, Artist's Collection

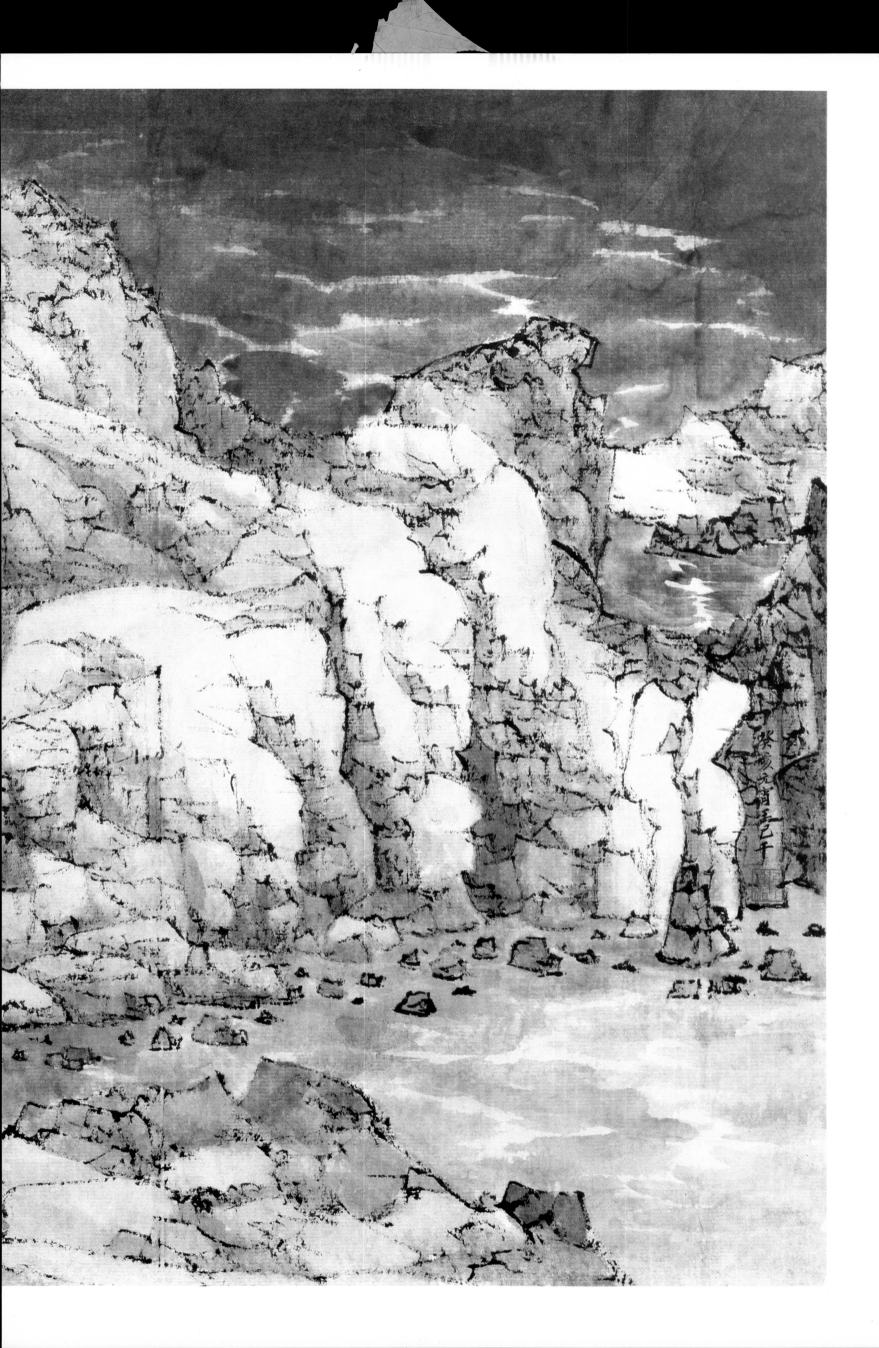

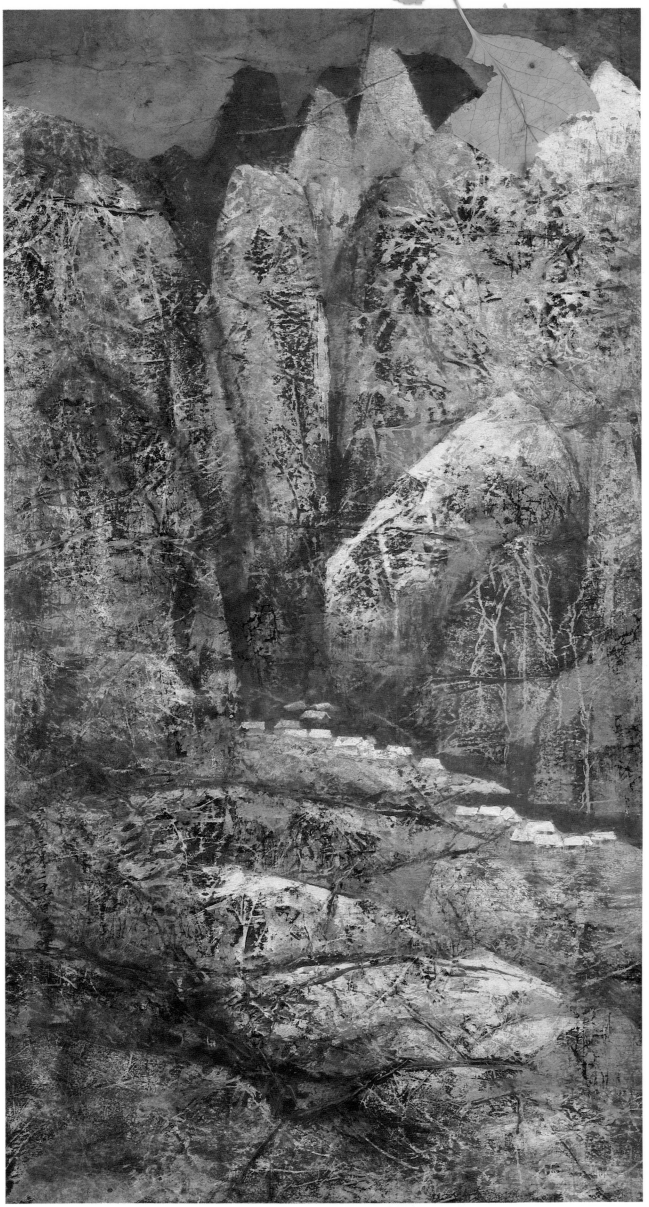

Landscape #464, dated 1983, 66 × 34 cm, Peter Neaman Collection

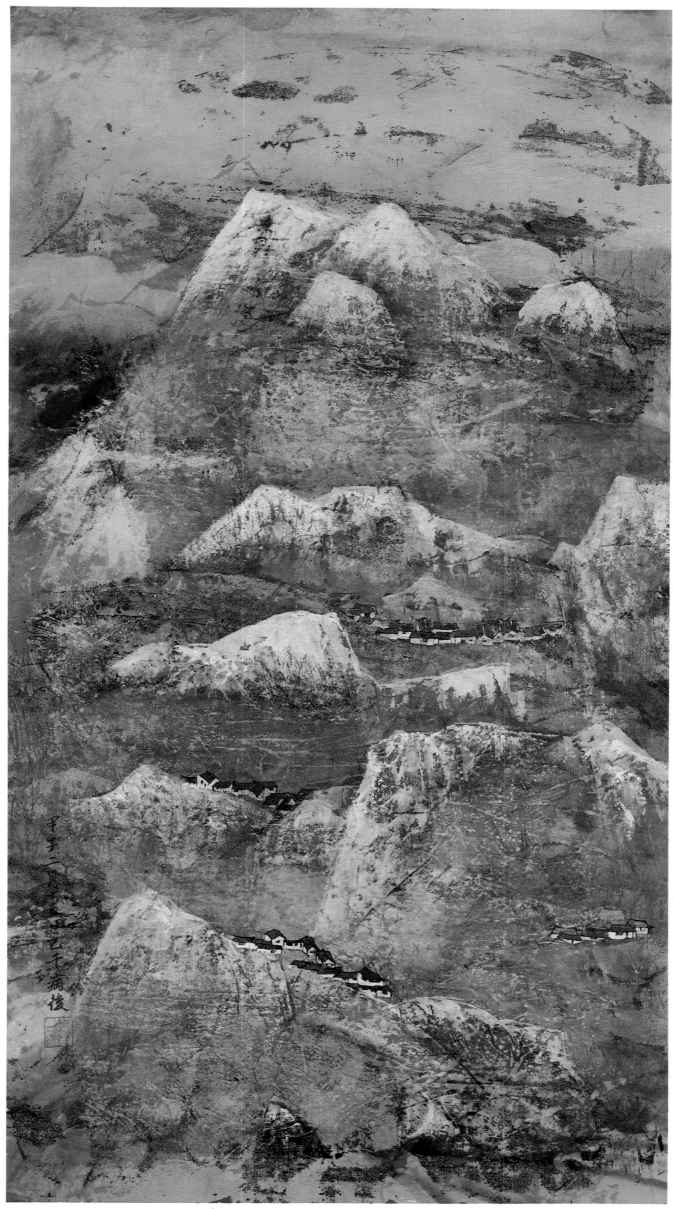

Landscape #483, dated 1984, 64.3 × 34.8 cm, Mr. and Mrs. Wayne G. Quasha Collection

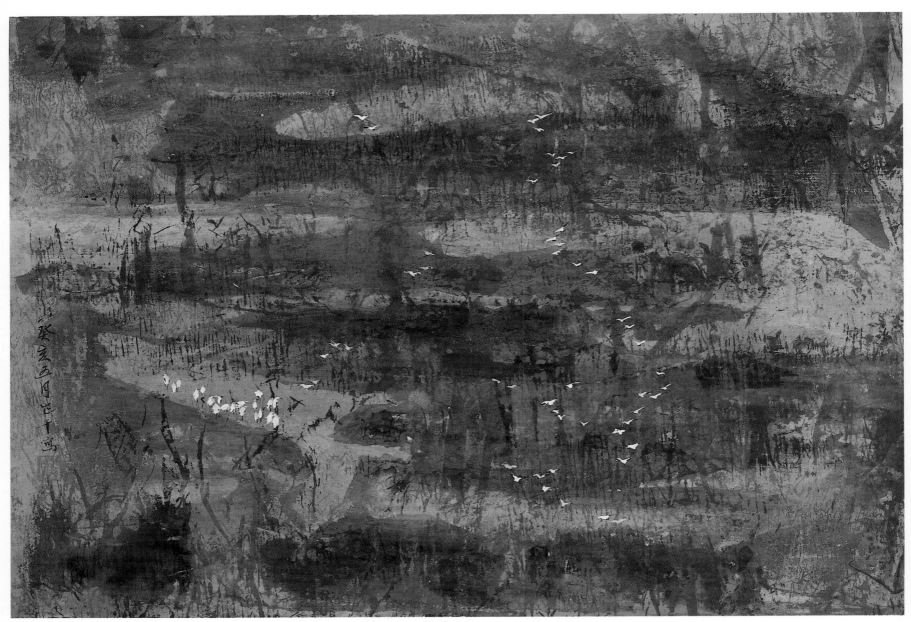

Landscape #485, dated 1983, 39.5 × 56.9 cm, Shuisongshi Shanfang Collection

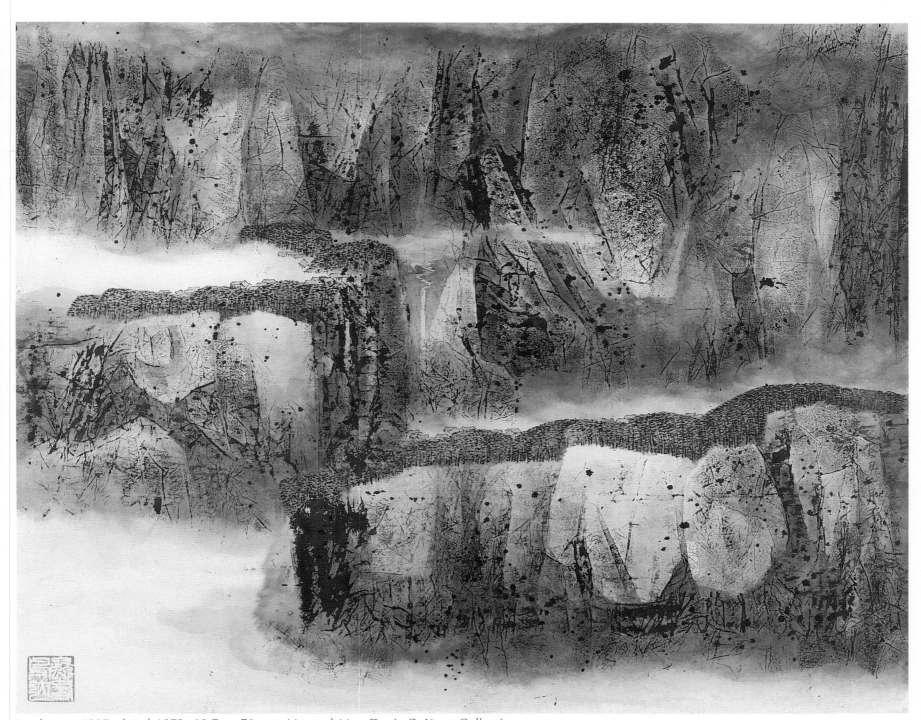

Landscape #227, dated 1973, 60.7 × 76 cm, Mr. and Mrs. Denis C. Yang Collection

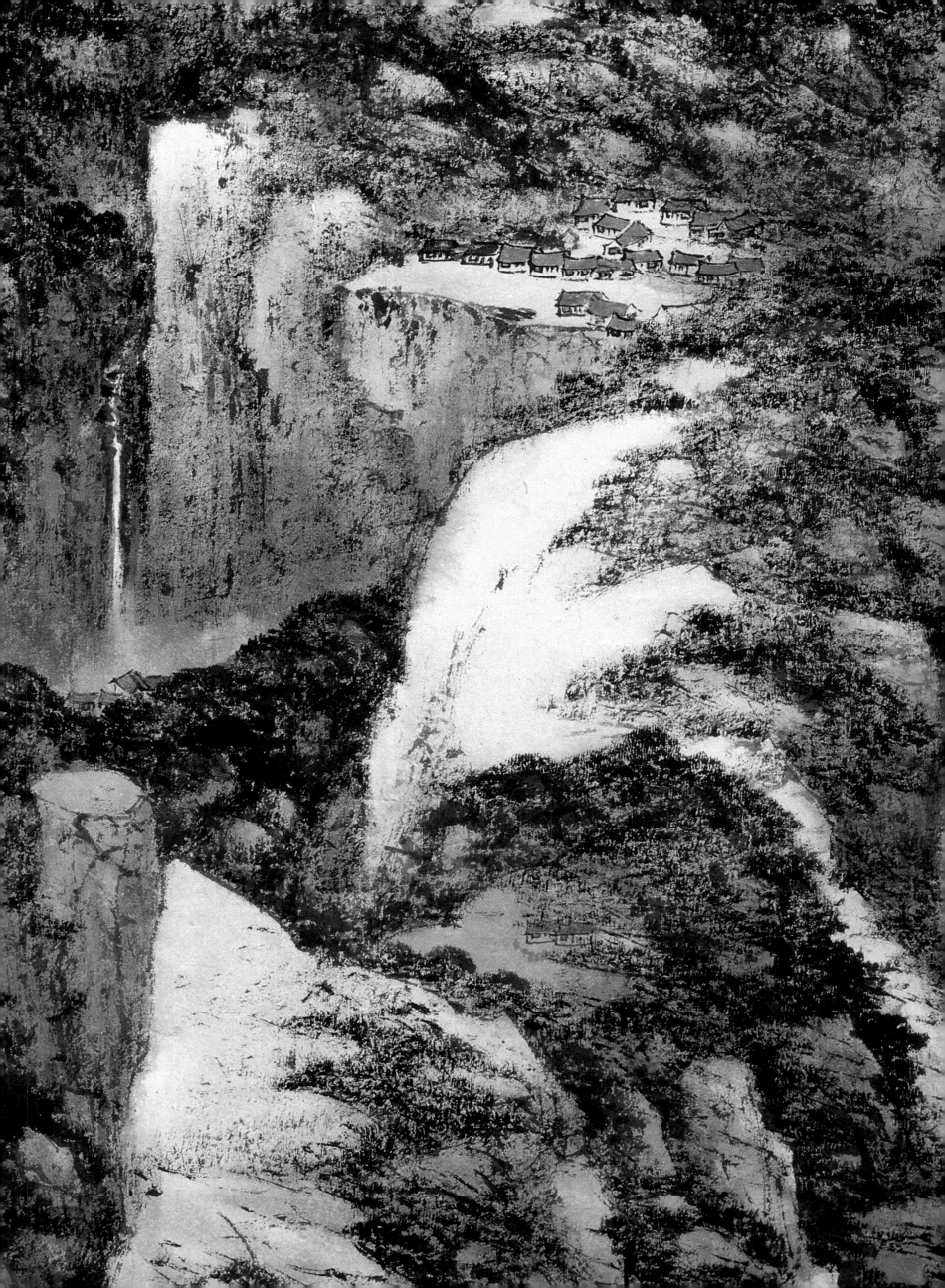

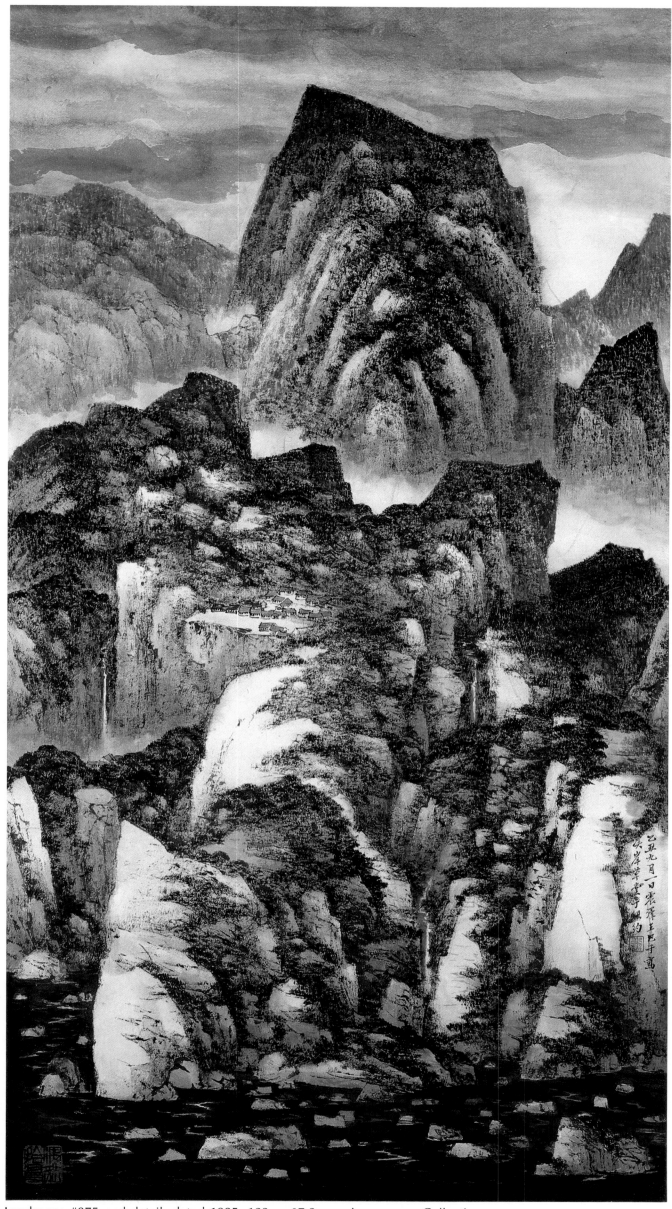

Landscape #875 and detail, dated 1985, 123 × 67.3 cm, Anonymous Collection

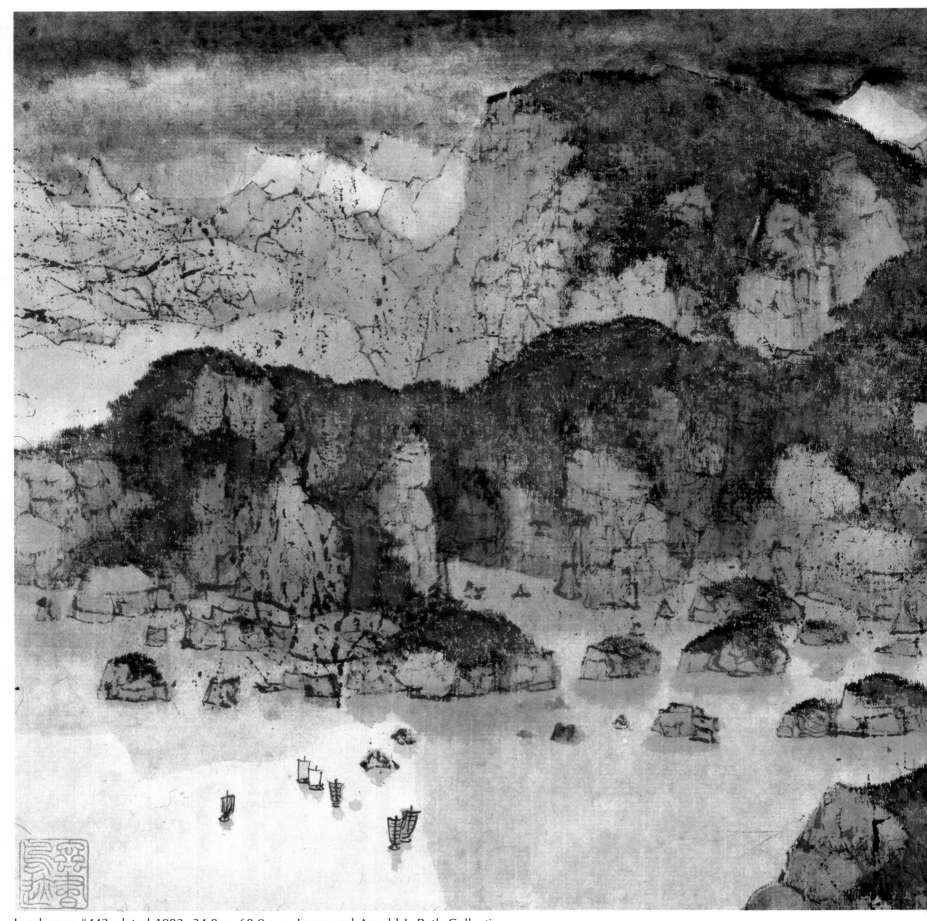

Landscape #442, dated 1982, 34.8 × 68.9 cm, Joyce and Arnold I. Roth Collection

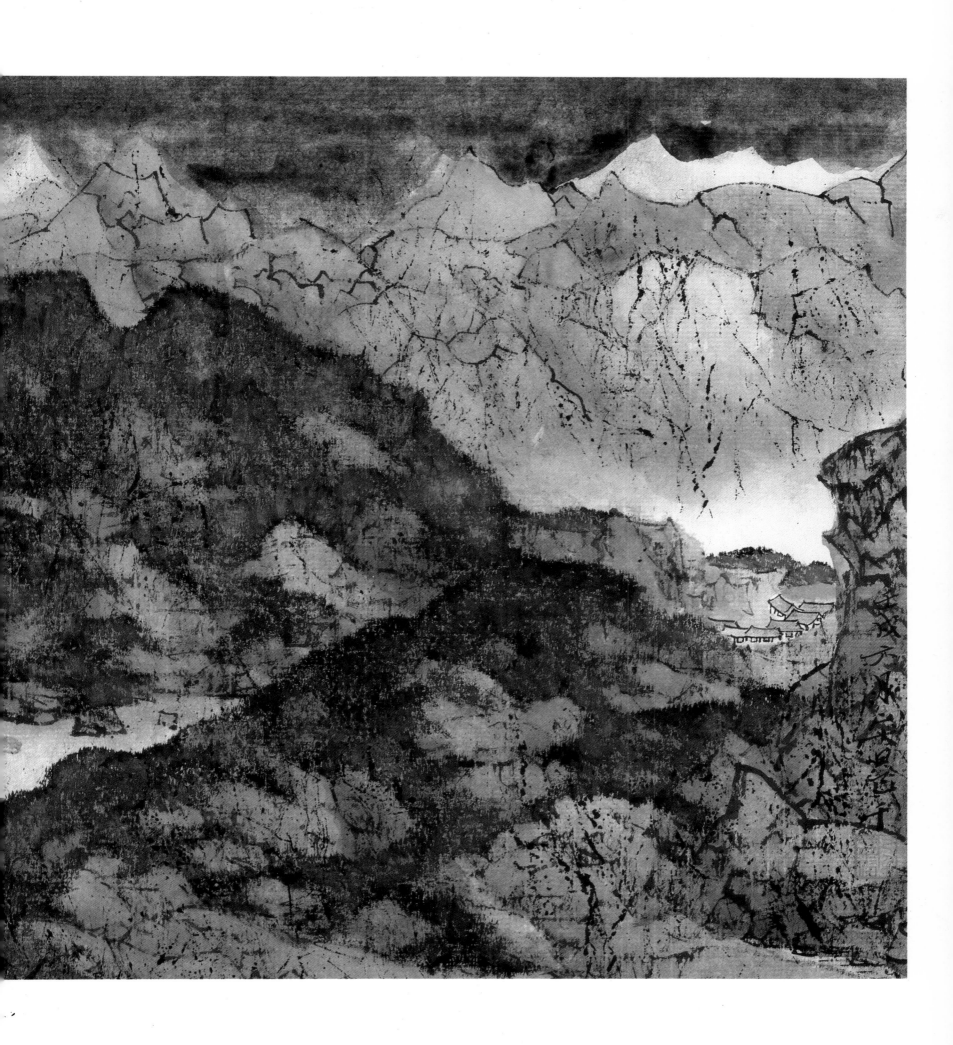

Chinese Seals and Their Place in Chinese Painting

Chinese art differs fundamentally from Western art in premise, approach, execution and effect. This becomes apparent during any prolonged period of observation and study of the subject. The appreciation of seals is especially difficult for those viewers, Western or Chinese, who are not literate in the archaic forms of the written Chinese language. The common questions about seals are: How did seals originate? What do they mean? and How are they used? It is hoped that this brief and general discussion of the history of seals and of their relationship to painting will answer these questions and enhance the viewer's enjoyment and appreciation of Chinese painting.

The History of Seals

Seals have been unearthed from some of China's early archaeological sites, dating back to the Shang dynasty (1523-1028 BC), almost the beginning of Chinese civilization itself. The first seals were used either privately, by merchants in trade transactions, or officially, to assert authority in conjunction with important messages. The use of the seal was especially important if the contents of the message were confidential. The message was first written on thin slats of bamboo or wood which were then tied together, horizontally, in reading sequence. (It is thought that the Chinese custom of writing in columns from top to bottom, and then proceeding from right to left, may have arisen from this ancient procedure.) The bamboo slats were rolled up, with the message on the inside, and tied with cord. Finally the bundle was covered by a piece of wood and a patch of fine clay, into which a seal was pressed. The seal impression served a dual purpose: first, it identified the sender and origin of the message; second, its intact form assured the recipient that the message had not been opened or tampered with in any way during transport. Such positive identification and assurance of confidentiality were of great importance to the emperors and military leaders of ancient China.

Ancient seals were cast in a mold or carved directly in metal, usually bronze, but also gold, silver, and iron. The seals, which were first modeled and carved in wax before casting, were characterized by deep, wide strokes. Seals carved after casting generally had shallower and less carefully incised strokes, since they were executed more rapidly. During the late Chou period (c. 300 BC), seals were worn on the belts of officials. Modern archaeological excavations have revealed "seals of office" buried with officials in their tombs, evidence of the importance attached to seals in ancient times.

The concept of the "seal of office" was elevated by the first Ch'in emperor (reigned 221-207 BC), who, shortly after unifying the country, commissioned six imperial seals to represent the authority invested in him by the Mandate of Heaven. It was believed that the emperor was granted divine permission to rule, provided that he rule in accordance with Heaven's ways. A seventh commissioned seal proclaimed him as the Son of Heaven. Thus, from very early times, seals were invested with a certain aura of authority which is still perceptible to this day.

Imperial seals differed from all others in several ways. Originally only imperial seals were permitted to be made of jade, and contain the word *hsi* 璽 , reserved for royal use only, from the many words meaning "seal" in the Chinese language. Most non-imperial seals contain the character *yin* 印 or *chang* 章 , which also mean "seal."

The tremendous symbolic importance of seals can be perceived in the tradition of *ch'uan kuo hsi* 傳國璽 , literally "passing down the seal of suzerainty," also established by the first Ch'in emperor. This tradition was based on the idea that rightful authority to rule the country resided with whoever possessed the seals of state. Thus, seals of state were to be carefully guarded and passed on from generation to generation within the dynastic family.

The first great period of development in seal carving occurred during the Han dynasty (221 BC-AD 220), coinciding with the rapid political, economic and cultural advances taking place simultaneously in China. Seal production increased in volume, and the use of seals was prevalent among officials of all levels, and among private users as well. Besides official seals, informal seals were popular, containing personal names or auspicious sayings. Han seals have been copied by seal carvers through the ages, for the Han style embodies a certain aesthetic refinement that has been held in high esteem from ancient times up to the present day.

The use of seals as signatures on painting began to appear around late T'ang or early Northern Sung (c. 10th century AD). Prior to that time, a seal on a painting was likely to be a collector's seal, such as that of the T'ang emperor T'ai Tsung (reigned AD 627-50), an early connoisseur of fine painting and calligraphy, whose imperial stamp was indication that a work had come into his royal possession.

It was not until the Yüan dynasty (1260-1368), with the advent of Chao Meng-fu 趙孟頫 , that seals came to be carved by scholars, and so began to take on more artistic forms. The tradition of seal carving underwent a renaissance, progressing along a course of rich stylistic development. This period was characterized by innovation and individual interpretation, which nonetheless did not stray far from ancient forms.

Throughout the Ming dynasty (1368-1644) outstanding masters attracted followers, a trend which brought about the proliferation of various "schools" of seal carving specializing in particular techniques or visual styles. It was during this time, too, that the use of stone, especially soapstone, was popularized by the famous painter, calligrapher and seal carver, Wang Mien 王冕 . The widespread acceptance of soapstone comes from the fact that not only was it plentiful and pleasing in its many subtle and colorful varieties, but was also much easier to cut than other materials such as jade, agate, crystal, and ivory. The process of refinement in the art of seal carving continued well into the Ch'ing dynasty (1644-1911), when it can be considered to have reached formal maturity.

This brief historical overview of seal carving provides a basis for understanding the nature and function of seals today. In their traditional capacities as means of identification and authentication and as symbols of authority, seals are still used today. Those who are likely to use seals frequently are collectors, artists, scholars, and government agencies. As in the past, there are official and private seals. Even today, in the People's Republic of China an essential step in the bureaucratic process is the proper "seal-stamp," without which a signature is of little significance.

Types of Collectors' and Painters' Seals

Private seals tend to be the possessions of collectors, artists and scholars. Collectors' seals are used on paintings, calligraphy, books and rubbings. Collectors' seals usually carry the name of the owner, and perhaps other information, autobiographical or otherwise, as well. It has been the habit, over the centuries, for collectors to affix their seals directly on a work of art, usually in an unobtrusive area of the piece. However, on some famous works, the proliferation of seals unfortunately begins to interfere with the aesthetic enjoyment of the piece. Nevertheless, collectors' seals are important in helping to determine the authenticity of a work. The various collectors' seals are a source of historical documentation, indicating how often a piece has changed ownership, and more importantly, through which owners it has passed. Since there has been an extremely long tradition in China of copying and working in the style of various famous old masters, not to mention outright forgery, seals provide one method of verifying a painting's authenticity. It should be noted, however, that collectors have occasionally erred in their judgement, so that the presence of a genuine seal does not necessarily guarantee the genuineness of a work. In determining authenticity, seals are but one of the many factors to be considered.

An exceptional piece in a collection may inspire the creation of a special commemorative seal. Among C.C. Wang's seals there are several which refer to the masterpiece, *The Procession of Taoist Immortals to Pay Homage to the King of Heaven* 朝天仙仗圖卷 by Wu Tsung-yüan 武宗元 . One such seal is *Pao Wu T'ang* 寶武堂 , which means, "The Hall that Treasures the Wu [painting]." This seal has become a reference to C.C. Wng's studio, another name by which C.C. Wang is known.

In similar spirit, the studio name can be seen as a memorial to an especially esteemed artist. An example is the seal bearing the characters *Huai Yün Lou* 懷雲樓 , which can be interpreted as "The Studio for Remembering Ni Tsan." Ni Tsan 倪瓚 is a Yüan dynasty master especially admired by C.C. Wang. This studio name also occurs on a few of the collector's seals, serving as another means of identifying C.C. Wang without direct use of his name. Other studio seals bear the name "Bamboo Studio 竹里館 ," a reference to one of the three symbolic "winter friends" of the scholar/artist: pine, bamboo and plum blossom.

The largest groups of private seals, however, are name and "leisure" seals. Name seals may be classified in two ways. One type consists of family names, or given names, or both, and includes the many types of Chinese nicknames. A Chinese artist usually prefers to be identified not by his actual given name, but by his nickname, poetic name or studio name. A second type of name seal may be thought of as "autobiographical" because it provides information on some aspect of the artist's background. Typically, this may be the name of the town or area of the artist's birth, a reference to his ancestry, the cyclical year of his birth, the animal representing the zodiacal sign under which he was born, and so on.

At the most simple and basic level, the name seal is a form of signature, identifying the artist, and add decorative value to a work of art. Though a Chinese artist may sign his name in ink, he will not consider the signature complete without a seal. Often, for a sense of aesthetic balance, he will affix more than one seal. In this way, the use of the seal is quite different from the Western artist's signature. The Chinese artist must collect numerous name and leisure seals, carved in many styles, for the purpose of having expressly the right one to match a work properly in mood and sensibility.

Leisure seals differ from name seals in that the content of leisure seals is aimed at expressing sentiments and aspirations rather than conveying facts. They are often short expressions in the form of a phrase from a famous poem or essay, well-known auspicious epigrams (such as "long live ..."), or idiomatic sayings which can be interpreted as philosophical reflections. The leisure seal provides a means of expression in a literary, as distinct from pictorial, way, complementing the artistic creation in a manner that is at once concise, aesthetically integrated and revealing of thoughts and feelings. A leisure seal, if quoting a famous poet or artist, may conjure up a whole host of meanings and associations in the space of a few characters; such is the beauty of its brevity. Although considered a minor art form of the literati since the Yüan dynasty, seal carving nevertheless interrelates on a profound level with painting and calligraphy.

The Relationship of Seals to Paintings

The way in which a seal complements a painting is most interesting. In many ways, a seal could not be more different from a painting: it has no tonal range (being pure vermilion), in contrast to the rich tonal gradations in monochrome ink or watercolor painting; moreover, in terms of content, seals are literal, based on characters, while paintings, based on images and textures, are pictorial. Although the carved seal is itself unique, the signature impression is always a print, or a duplication. This is in contrast to the painting, which is an original, as well as to the Western idea of a signature.

The seal maintains its integrity as a complete, unified, separate entity despite its subordinate size and position relative to the painting. Notwithstanding these differences, the seal is linked to the painting, physically and conceptually, as a fixed, integral part of the overall composition. Seal carving shares common roots with painting, in calligraphy. The scholars, or literati, who excelled in the academic arts, had extensive knowledge of the Chinese language and long years of experience in the discipline of calligraphy, the vehicle for the artistic expression of the written language. The degree to which painting was, and still is, influenced by calligraphy is apparent in the fact that one major criterion for judging an artist is the quality of his "calligraphic brushwork."

Just as literati painting is characterized by "calligraphic brushwork," so too may seal carving be thought of as "calligraphic knifework." Both are based on the quality of the line drawn by a brush; consequently, seal carving is often judged by calligraphic standards and it is not surprising that many great calligraphers and painters are also accomplished seal carvers. The seal artist requires mastery of calligraphy, not only for the forming of individual characters, but also for the sense of design needed to compose the characters into an aesthetically satisfying seal.

There are several main written forms for Chinese characters: *k'ai* 楷 , the modern printed form; *hsing* 行 and *ts'ao* 草 , the two cursive styles still in common use today; *li* 隸 , the ancient clerical style; and *chuan* 篆 , the ancient predecessor to *li*, known as seal style or archaic style.

A seal may be executed in any of these scripts, but the one most commonly encountered is the archaic script. The term "archaic script" denotes a broad category, encompassing many ancient forms of writing which have long since passed out of popular use. These include large seal, small seal, bird script, insect script, and bronze inscription script, to name just a few. A good seal carver, then, must not only understand calligraphy, but also be well versed in the history of the Chinese written language in order to convert a modern character into the various archaic forms. The predominance of the archaic script above all others in seal carving may be accounted for by the following reasons. First, the archaic characters, being rarely encountered under ordinary circumstances, attract more attention but are less easily imitated than ordinary characters; this is important in the context of signature seals. Second, a seal in archaic script is a status symbol, pointing to the erudition of its owner, who presumably has had the leisure to pursue education and refinement in the arts. Third, there is the concept of "the antique spirit" in Chinese art, which can be seen as homage to tradition. The first seals, dating from Han and pre-Han times, were originally carved in the script now known as "archaic." On another level, however, the idea of striving for "the antique spirit" reflects a desire to

understand the artistic evolution of tradition, through which process one may eventually innovate upon and beyond tradition. The fourth, and perhaps most logical, reason stems from both practical and aesthetic considerations. From the carver's point of view, the archaic characters are much more adaptable to permutations than any other written form: they can be stretched horizontally or vertically, the lines can be straight or curved, with the option of adding or deleting strokes in certain places as necessary to make a character achieve the seal carver's intention within the overall composition. Thus, the archaic script offers considerably greater artistic variation within the small space of a seal than is possible with the other written forms, which are not open to such permutations without loss of legibility or aesthetic balance. Finally, the many sub-categories of archaic characters more closely resemble the original pictographs or ideographs of Chinese characters than do the later forms, lending a more decorative effect to seals. These possibilities make the archaic form more appealing to seal carvers as a medium of creative expression.

Calligraphy, as mentioned earlier, is one pivotal point around which painting and seal carving interrelate; another is the Taoist principle of sustaining a harmonious balance between two complementary forces. In painting, calligraphy and seal carving, scrupulous attention is paid to the interaction of positive and negative space, the equilibrium between light and dark. Separately, all three art forms strive to achieve equilibrium within themselves; at the same time, they can be observed together as a complementary set, contrasting yet interconnected with each other. A new dynamic tension is created in the juxtaposition, which expands the realm of appreciation within the work of art.

It is apparent, therefore, that the placement of the seal on the painting cannot be totally arbitrary, yet it will also be noticed that there does not seem to be any fixed position where most seals appear on a painting. The joining of seal to painting is a three-step process. First, the proper seal or seals must be chosen in keeping with the meaning and sensibility the artist wishes to convey to his audience. Second, the compositional integrity of the painting must be respected, namely, that the seal must be placed in such a way as to enhance the composition, not interfere with it. Since every painting is unique, there cannot be a single absolute location for the seal. The determination of the most effective placement is an intuitive search for just the right aesthetic balance, after all formal factors have been taken into consideration. As might be surmised, there cannot be any immutable rules, as each artist will manifest individual taste and discernment in this area. The final step is the actual affixing of the seal to the painting. This is done by first lightly tapping the seal base to the vermilion ink to get a smooth, even contact with the ink. Once placed, the seal is pressed down and pressure is applied to the center and all four corners, or to the edges if the seal is of an irregular shape. A few seconds are allowed to ensure that the impression emerges rich and strong. It should be borne in mind that the whole process is fluid, the artist proceeding not in formulaic steps, but in receptiveness to all the aesthetic influences that come into play.

Certain conventions have evolved through long use. For example, the usual practice is for seal impressions to flank the painting, unless otherwise closely accompanying calligraphy on the painting. It ws a custom during the Yüan dynasty and later for literati artists to leave space on their paintings for notable friends or contemporaries to write poems or commentaries. In the paintings of C.C. Wang, however, there is a noticeable lack of such calligraphy. One finds only the date, possibly a title, and his name. This absence is intentional, for the artist wishes to leave as much open to the interpretation and imagination of the viewer as possible, without words to distract or detract from the experience of the painting itself. Likewise, the application of seals is also sparing. Certain favorite seals appear more often than others, such as "Bird and Insect Tracks 蟲書鳥跡," which refers to an appreciation of naturalness, in the universe and in painting. In this way, a poetic suggestion is offered, which directs the viewer's attention to what the artist had in mind as he created the painting.

We see, in choice of message and placement of the seal on the painting, the way in which an artist can subtly impart his intention to the viewer as to how to approach his painting. Thus, seals are uniquely utilized in Chinese art to be expressive and to communicate meaning on many levels. We have explored the various uses of seals, whether they be name, leisure, collection or studio seals. Seal history, carving techniques and aesthetics, however, are still lesser known areas in Chinese art and relatively few publications on them are available in English. The ones I consulted are listed below. Some of the observations made in this essay have come from personal experience through the actual practice of seal carving. I am indebted to Mr. Hsü Yün-shu and my grandfather, C.C. Wang, whose knowledge of seals and whose patience in sharing that knowledge have made this article possible.

Lynn King

References

Na Chih-liang, *Chinese Seals: the Collection of Ralph C. Lee* (Taiwan, privately printed by Allan Lee, 1966)

Tsien Tsuen-Hsuin. *Written on Bamboo and Silk: the Beginnings of Chinese Books and Inscriptions,* (University of Chicago Press, 1962)

Wang Ren Cong, "Han Dynasty Seals," *Orientations,* August 1984, pp. 12-17

Yeh Ch'iu-yuan, "The Lore of Chinese Seals," *Tien Hsia Monthly,* Vol X, No. 1, January 1940, pp. 9-22

The Seals

Personal Name and Private Seals

1	2	3
4	5	6
7	8	9
10	11	12

1. Wang Ch'ien
 遷王

2. Chi-ch'ien
 季
 遷

3. Wang Chi-ch'ien's seal
 遷王
 印季

4. Wang Chi-ch'ien
 己王
 千

5. Chi-ch'ien
 遷季

6. Work created by Chi-ch'ien
 創己
 稿千

7. May Chi-ch'ien have long life
 長季
 壽遷

8. Work created in America by Chi-ch'ien
 之旅季
 作美遷

9. Wang Chi-ch'ien
 季王
 遷

10. Chi-ch'ien
 遷季

11. Wang Chi-ch'ien's seal
 遷王
 印季

12. Wang Chi-ch'ien's calligraphy and painting seal
 書王季
 畫遷
 記

13. Chi-ch'ien
遷季

14. Copied by Chi-ch'ien
季遷臨本

15. Wang Chi-ch'ien's seal
千王
鈢己

16. By Chi-ch'ien
製己千

17. Chi-ch'ien
遷季

18. Chi-ch'ien's painting seal
畫季遷記

19. Wang Chi-ch'ien's seal
季王
遷印

20. Chi-ch'ien's and Yüan-su's collaboration seal
作元季
之素遷
印合

21. Chi-ch'ien
千己

22. Wang Chi-ch'ien's seal
之一王季遷
印字己千
信

23. With the compliments of Chi-ch'ien
拜季
贈遷

24. Wang Chi-ch'ien's seal
遷王
印季

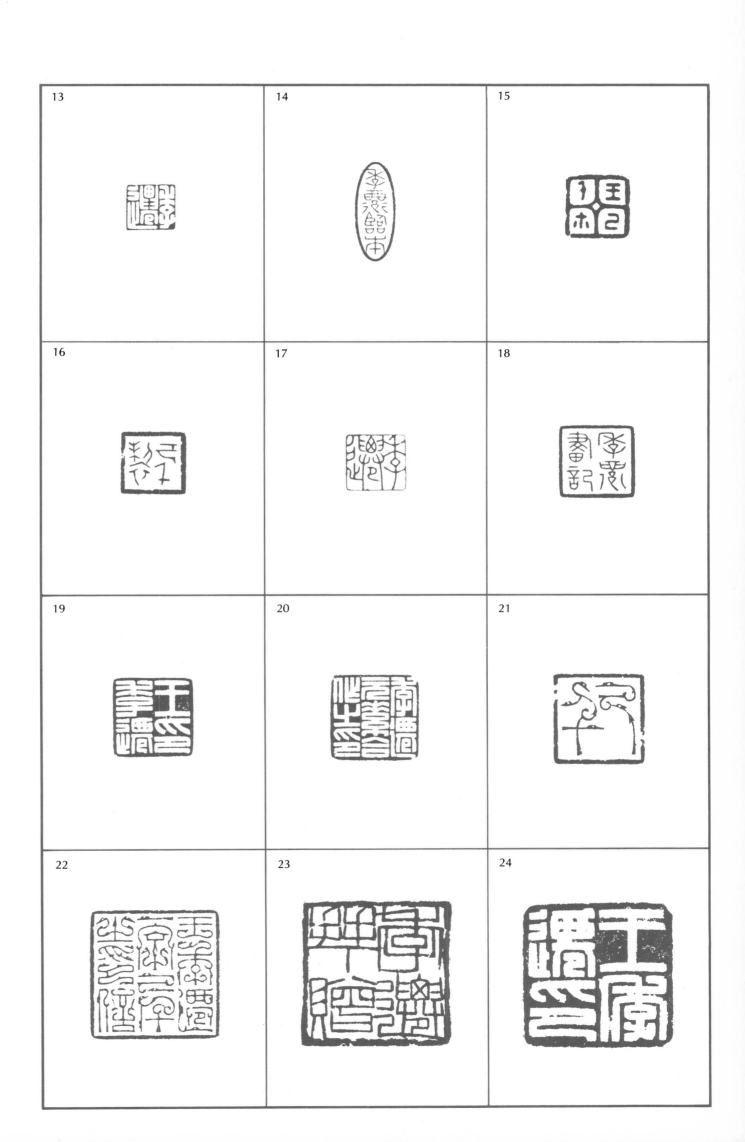

25

26

27

28

29

30

31

32

33

34

35

36

Collection and Studio Seals

1. Bamboo Studio
 館竹里

2. Appreciated by Chi-ch'ien
 心季賞遷

3. Seal of the Bamboo Studio
 館竹印里

4. Studio for Remembering Ni Tsan
 樓懷雲

5. Bamboo Studio
 館竹里

6. Twin Wood Studio
 書雙屋林

7. Treasured by Chi-ch'ien
 珍季藏遷

8. Had been in the collection of the
 Bamboo Studio
 竹里曾館歸

9. Hall of Treasuring the Wu Painting
 堂武寶

10. Hall of Treasuring the Wu Painting
 武堂寶

11. Seal of the Hall of Treasuring the
 Wu Painting
 堂寶印武

12. Studio for Remembering Ni Tsan
 樓懷雲

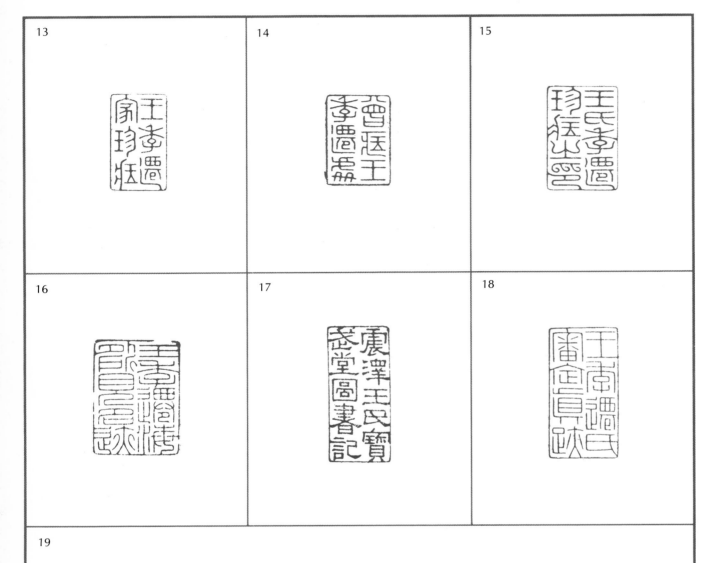

13. Treasured by Wang Chi-ch'ien's family

家王
珍季
藏遷

14. Had been in the collection of Wang Chi-ch'ien

季曾
遷藏
處

15. Seal of Wang Chi-ch'ien's treasured collection

王
氏季
遷
珍
藏之
印

16. Famous work seen by Wang Chi-ch'ien outside China

外王
所季
見遷
名海
跡

17. Seal of the Hall of Treasuring the Wu Painting of the Wang family from Lake T'ai

震
澤王
氏
寶
武堂
圖
書記

18. Genuine work authenticated by Wang Chi-ch'ien

王
審季
定遷
眞氏
跡

19. The calligraphy and painting authentication seal of the Studio for Remembering Ni Tsan

懷
鑑雲
畫賞樓
之書
記

20. Studio for Remembering Ni Tsan
懷
樓 雲

21. Hall of Treasuring the Wu Painting
寶
武
堂

22. Collection seal of Wang Chi-ch'ien
of Lake T'ai
收 氏 震
藏 季 澤
印 遷 王

20

21

22

Leisure Seals

1. Refined
大雅

2. Studio for Self Improvement
補拙山房

3. Ink play by Wu-yen
無言墨戲

4. Though the ancients' methods are lacking, there is in this simplicity something of a personal style
雖無古法簡
拙自一家

5. Insect and bird tracks
蟲鳥書迹

6. Childlike innocence is not yet lost
童心未泯

7. Water marks from a leaking roof
屋漏痕

8. Mountains of the mind
胸中丘壑

9. Gradually going astray
漸道入魔

10. Following no one, not even oneself; neither ancient nor modern
無人無我
非古非今

11. Arrived at by accident
偶然拾得

12. Insect and bird tracks
蟲鳥書迹

13. Traveled ten thousand miles
里 行
路 萬

14. Plain and naïve
　 平
　 澹
眞 天

15. What is so good here are the beautiful colors that fill the eyes
　 好 此
妙 秀 中
滿 色 有
眼 　 何

16. The terrain in Chi-ch'ien's heart
心 季
境 遷

17. Just right
酒
佳
爾

18. Water marks from a leaking roof
　 屋
痕 漏

19. Insect and bird tracks
鳥 蟲
跡 書

20. Natural and naïve
天 爛
眞 漫

21. Neither Southern nor Northern School, but both ancient and modern
　 北 非
亦 亦 南
今 古 非

22. Beyond likeness
象 得
外 之

23. Beyond orthodoxy
　 野
禪 狐

24. Coming and going alone on the clear ripples in the bright moonlight
獨 清 晈
往 波 月
來

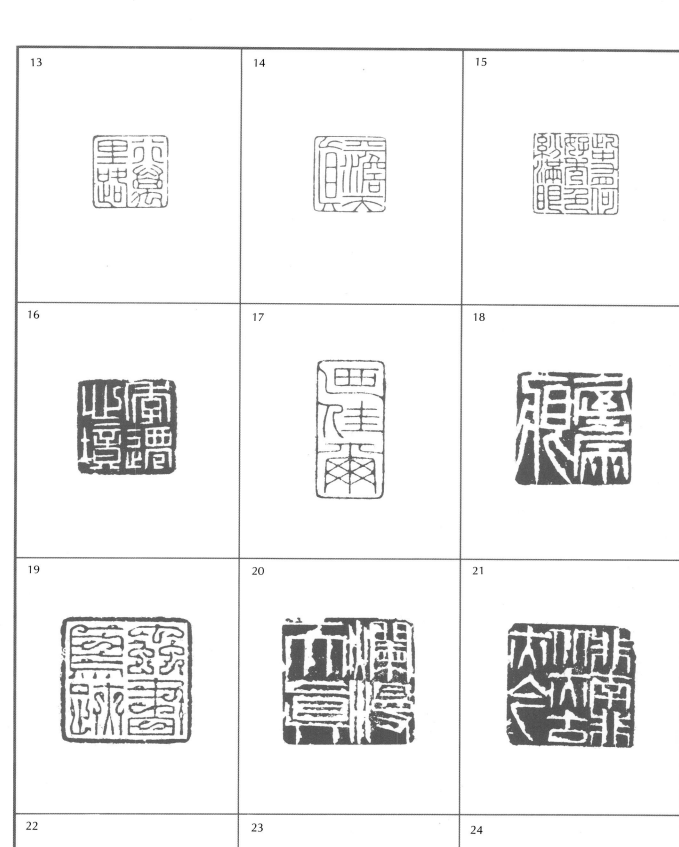

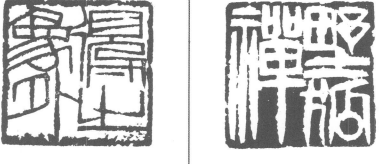

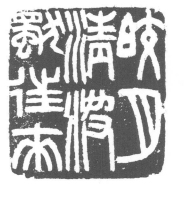

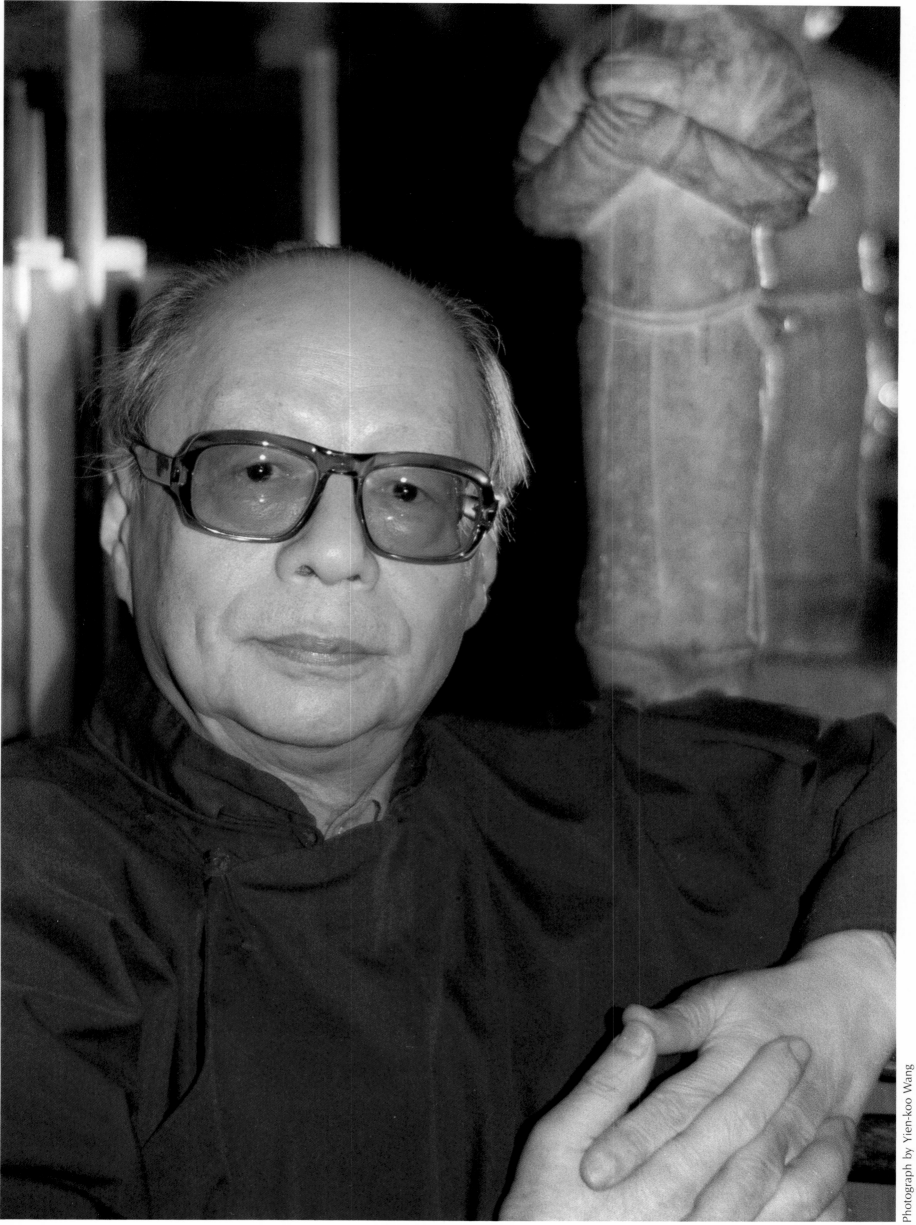

Wang Chi-ch'ien:
Painter, Collector, Connoisseur

Wang Ch'ien, alias Chi-ch'üan, is better known in the West as C.C. Wang. Native of Tung-t'ing-shan of Wu-hsien, Kiangsu province, he was born in Suchou in 1907. Wang received his early training in art from a well-known traditional painter and collector in Suchou, Ku Lin-shih (1865-1933). Later he went to Shanghai where he enrolled at the Suchou University to study law. However he continued his interest in Chinese painting and was fortunate enough to become the pupil of Wu Hu-fan (1894-1968), the leading orthodox painter and collector in Shanghai. Not only was he to receive a thorough training in the subtleties of the brush techniques of the old masters, he was also initiated into the world of connoisseurship as private and public collections of masterpieces were made accessible to him. Another breakthrough came around 1934-35 when he was appointed advisor to the Committee of the London Exhibition of Chinese Art. He had the unique opportunity of studying the entire painting collection of the Palace Museum. That Wang should develop into a world-renowned collector and connoisseur of Chinese painting is based on a combination of unusual opportunities as well as his own persistent efforts.

In 1940 Wang collaborated with German art historian Victoria Contag to compile *Maler-und Sammler-Stempel aus der Ming und Ch'ing-Zeit (Seals of Chinese Painters and Collectors of the Ming and Ch'ing Periods)*, which remains to this day an important standard reference for students of Chinese painting. During this period he also took up teaching positions in the academies of art in Suchou and Shanghai. In 1947 Wang toured the United States to study museum collections of Chinese painting, and two years later he and his family made their home in New York. Since then he has played an important part in promoting the study of Chinese painting, often invited to lecture at universities and to advise museums and collectors. Wang's broad knowledge of Chinese painting history and his extraordinary level of connoisseurship are highly respected by everyone connected with this area of study. Wang taught at the Fine Arts Department, New Asia College, Hong Kong, for a brief period in 1957 and returned in 1962 to take up the chairmanship and to teach courses in Chinese painting and connoisseurship until 1964.

In view of his study of ancient paintings, Wang's early works followed the Orthodox masters and continued the sophisticated and elegant styles of the later literati tradition. Since his removal to New York, he has come into contact with the modern artistic trends in the West. He discovered parallels between the spiritual expression of traditional Chinese painting and the abstract art of the West and subsequently joined the Art Students League in New York to expose himself to Western painting techniques. By 1962 when he was teaching at New Asia College he was gradually freeing himself from the confines of the literati tradition to experiment with bold and spontaneous brushwork techniques. He even applied ink by means other than the Chinese brush to create images new to Chinese painting. With crinkled paper he made ink impressions at random, after which the brush is again used to define the contours of mountains and rocks, and to add details of trees and houses.

His technical innovations merge the East and the West. They not only formulate his highly personal style, but also establish him as a pioneer in the development of modern ink painting. He continues to develop as a creative and innovative artist, and at the same time is firmly rooted in tradition, providing solutions to the modernization of Chinese painting that will ultimately determine his place in the history of modern Chinese art.

Since the 1960s Wang has held exhibitions of his new paintings in major museums and universities, including the de Young Museum of San Francisco, the Fogg Museum of Harvard University, Boston, and the Los Angeles County Museum. Of particular significance is his one-man show sponsored by the Sackler Foundation which toured the United States in 1977.

王己千——
畫家・收藏家・鑑賞家

王己千，初名季銓，後改名季遷，又名紀千。江蘇吳縣洞庭山人，1907年生於蘇州，現年80歲。少年時即隨蘇州名家顧麟士(1865—1933)習畫。後赴上海東吳大學進修法律，不忘繪畫。獲上海名書畫家與收藏家吳湖帆(1894—1968)收爲入室弟子，不僅藝事大進，更飽覽海上公私書畫收藏，1934—35年間應邀出任「倫敦中國藝術國際展覽會」籌備委員會顧問，因得精研故宮博物院全部書畫名蹟。王氏能成爲當今世界知名之畫家、收藏家及鑑賞家，自因其不可多得的機緣及持續不斷的努力。

王氏曾於1940年與德國孔達女士合著《明淸畫家印鑑》一書，至今仍爲研究中國書畫必備的參攷書。此外，歷任蘇州及上海美術專科學校教授。1947年曾赴美國考察各大博物館之中國書畫收藏，並於1949年定居紐約，多年來致力於推廣中國書畫之研究及鑑賞，經常應邀訪問各大學及博物館講學或指導。其淵博之書畫知識及精深之鑑別造詣，備受敬重。王氏於1957年間曾任敎於香港新亞書院藝術系，又於1962—64年應聘任該系系主任，並講授國畫及書畫鑑賞課程。

王氏旣精於鑑藏，其早年之畫作，多守古法，屬溫文典雅之文人畫傳統。旅居美國後接觸西歐現代畫派，得悟中國傳統繪畫精神與現代抽象藝術實有契合之需，乃毅然加入紐約之藝術學生聯盟進修西洋繪畫基本課程。至1962年在新亞書院任敎期間，已漸脫古人桎梏，以豪放自由之筆墨，寫胸中丘壑，甚至放棄傳統國畫所倚重之毛筆，以紙摺皺拓印，隨意塗抹，任其成形，再略加山水樹石，點綴村落，遂創建其融會中西之獨特風格，亦使王氏成爲開拓現代水墨畫新域之前驅。王氏此植根傳統而不斷創新的精神，實在足爲現代中國畫壇之典範。

王氏自六十年代即在美國著名大學及美術館舉行個展，包括三藩市棣揚博物館、波士頓哈佛大學福格博物館，洛杉磯市立美術館等，而以1977年美國沙可樂基金會主辦之全美巡迴個展最爲特出，備受藝術界佳評。

Selected One-man Shows

1950 Warren E. Cox Galleries, New York, New York

1959 Mi Chou Gallery, New York, New York

1968 M.H. de Young Memorial Museum, San Francisco, California

1971 Retrospective Exhibition, Los Angeles County Museum of Art, Los Angeles, California

1972 Indianapolis Museum of Art, Indianapolis, Indiana

1972 China Institute in America, New York, New York

1972 Honolulu Academy of Arts, Honolulu, Hawaii

1973 Fogg Art Museum, Harvard University, Cambridge, Massachusetts

1973 The New Gallery, Schacht Fine Arts Center, Russell Sage College, Troy, New York

1973 Chinese Cultural Center, New York, New York

1973 New Paltz State University, New Paltz, New York

1975 Columbia University, New York, New York

1976 Eastern Illinois University, Charleston, Illinois

1976 Chinese Culture Foundation of San Francisco, California

1977 North Carolina Museum of Art, Raleigh, North Carolina

1977 Brooklyn Museum, Brooklyn, New York

1979 Museum of Art, The Pennsylvania State University, Pennsylvania

1983 Hong Kong Arts Centre, Hong Kong

1985 Taipei Fine Arts Museum, Taiwan, Republic of China

1986 Hong Kong Arts Centre, Hong Kong

Selected Group Exhibitions

1966 "The New Chinese Landscape: Six Contemporary Chinese Artists," circulated throughout the United States, under the auspices of the American Federation of Arts, New York, New York

1971 "Chinese Painting at Mid-century," Renaissance Society, University of Chicago, Chicago, Illinois

1972 Three-man Show, Seton Hall University, New Jersey

1974 Group Show, Watercolor Society, National Academy of Art and Design, New York, New York

1981 "Paintings by Wu Hufan and His Students," Shanghai, People's Republic of China

1982 Group Show, Moss Gallery, London, England

1984 Group Show, Museum of Modern Art, Taipei, Taiwan, Republic of China

1985 Group Show, Hong Kong Arts Centre, Hong Kong

1986 "The Mountain Retreat: Landscape in Modern Chinese Painting," The Aspen Art Museum, Aspen, Colorado and the Emily Lowe Gallery, Hofstra University, Hempstead, New York

1986 "Hong Kong Art: 1970-1980," Leal Senado de Macau, Macau

1986 "Contemporary Chinese Painting," Exhibition Hall, Hong Kong City Hall, Hong Kong

1986 "Modern Asian Ink and Color Paintings Exhibition," 10th Asian Games Arts Festival, Seoul, Korea

Study by C.C. Wang

Victoria Contag and Wang Chi-ch'ien, *Maler-und Sammler-Stempel aus der Ming und Ch'ing-Zeit. Seals of Chinese Painters and Collectors of the Ming and Ch'ing Periods* 明清畫家印鑑 (The Commercial Press, Shanghai, 1940; Revised Edition with Supplement, Hong Kong University Press, 1966)

Studies on C.C. Wang

Meredith Weatherby (ed.), *Mountains of the Mind: The Landscape Paintings of Wang Chi-ch'ien* (Walker/Weatherhill, New York and Tokyo, 1970)

Jennifer S. Byrd, "The Last Literatus," *Asian Pacific Quarterly of Cultural and Social Affairs,* Summer 1974, Vol. VI, No. 1, pp. 1-15.

The Landscapes of C.C. Wang: Mountains of the Mind (The Arthur M. Sackler Foundation, Washington, D.C., 1977)

Li Chu-tsing, *Trends in Modern Chinese Painting: The C.A. Drenowatz Collection,* (Artibus Asiae, Ascona, 1979), Chapter VIII, pp. 176-81

Hugh Moss, *Some Recent Developments in Twentieth Century Chinese Painting: A Personal View* (Hong Kong, 1982), pp. 20, 57, 65, 89, 91 and 97

Kao Mayching (ed.), *Special Publication in Commemoration of the 25th Anniversary of the Fine Arts Department, The Chinese University of Hong Kong* (The Chinese University of Hong Kong, 1982), p. 24

Arnold Chang, "The Landscape Paintings of Wang Jiqian," *Orientations,* January 1983, pp. 26-39

Joan Stanley-Baker, "A Significant Event for China," *Free China Review,* September 1983, pp. 53-8

Hugh Moss, *The Experience of Art: Twentieth Century Chinese Paintings from the Shuisongshi Shanfang Collection* (Hong Kong, 1983) pp. 78-89

Wai-fong Anita Siu, *The Modern Spirit in Chinese Painting* (Phoenix Art Museum, 1985), pp. 76-7.

Hsü Hsiao-hu, a series of interviews with C.C. Wang on Chinese painting in *The National Palace Museum Monthly,* Nos. 13-29, April 1984-August 1985

Contemporary Chinese Painting (The Chinese University Press, Hong Kong, 1986), pp. 19-21 and pp. 119 and 130

Arnold Chang and Brad Davis, *The Mountain Retreat: Landscape in Modern Chinese Painting* (The Aspen Art Museum, Aspen, Colorado, 1986), pp. 72-5

Joan Stanley-Baker, "A Closed Cycle in Chinese Art," *Free China Review,* July 1986, Vol. 36, No. 7, pp. 10-27